T0286042

Apples, Cherries, Hops: Kent's Food and Drink

Naomi Dickins

AMBERLEY

Dedicated to my family with fond thoughts of our own, special, foodie traditions and of shared meals around our tables.

First published 2023

Amberley Publishing
The Hill, Stroud, Gloucestershire, GL5 4EP
www.amberley-books.com

Copyright © Naomi Dickins, 2023

The right of Naomi Dickins to be identified as the Author of this work has been asserted in accordance with the Copyrights, Designs and Patents Act 1988.

ISBN 978 1 3981 0181 4 (print)
ISBN 978 1 3981 0182 1 (ebook)

British Library Cataloguing in Publication Data.
A catalogue record for this book is available from the British Library.

Typesetting by SJmagic DESIGN SERVICES, India.
Printed in Great Britain.

Contents

Introduction – Kent's Farming Heritage

Not for nothing did Henry VIII dub Kent the 'Garden of England', but perhaps he might more accurately have described it as the kitchen garden of England, for this is a well-tended plot, with a long, proud history of innovation and successes in farming and food production. It is a garden of many parts, with a diverse topography ranging across its 1,400 undulating square miles of clay, chalk and sandstone; areas of dense woodland – much of it ancient – contrast with dramatic swathes of stark wetland wilderness; patchwork fields straddle rolling, downland hilltops and shelter in dry valleys; while 350 miles of rugged coastline gaze out towards the North Sea from the Thames Estuary to the English Channel. An annual rainbow cycles across this vista, signalling the phases of the agricultural year: the pastel palette of fruit blossoms and acid green of new shoots; the dazzling yellow of rapeseed and the glowing reds of soft fruits; the deep, golden gleam of ripe corn and russet blaze of the laden orchard; even the soft blue haze of lavender, each proclaiming the colourful cornucopia of culinary produce that comes with each harvest. Kent's is an eclectic landscape, and it is this regional variation which has given the area an edge when it comes to the production of food and drink. There is very little that will not grow somewhere in this county, nurtured by its bountiful soils and benevolent climate. From cereals to soft fruit, spring lamb to beer, in Kent, they know a thing or two about how to feed folk, and the county's long culinary tradition has grown from strong agricultural and maritime roots.

In the 500 years since Henry VIII bestowed the county with its motto, the scope of Kent's garden has expanded and it now supports some 2,500 independent food-producing businesses. The 15,500 people employed in the sector are the latest in the long line of those who have harnessed the abundance of this particular piece of England since its earliest recorded history. Today, among Kent's acres of fruit orchards, hop gardens and nut plats, you will find traditional brewers, bakers and winemakers alongside gin distillers, chocolatiers and wild food foragers. Flocks of sheep graze rich marshland and pasture, as they have for centuries, and the coastal bays and river estuaries are populated with fishing boats and oyster hatcheries reaping the bounty of the wild Atlantic. Ancient regional variations might not be quite as conspicuous in the twenty-first century as they once were but, prior to the Industrial Revolution, local distinctions were well defined and the county's food heritage is very much shaped by its landscape variations. Kent's northern edge, with its widely varied soil types,

has sustained great diversity of production, from the bountiful Tudor fruit gardens of Richard Harris at Teynham to sheep pasture along the Thames and Medway. This area's proximity to London was, for centuries, a key driving force behind its farmers' creative endeavours as they competed to satisfy the ever-increasing demands of the capital. The downland pastures were, arguably, some of the county's most profitable areas during the Middle Ages. This was sheep country, providing the raw material for medieval England's most valuable commodity, wool cloth, but sheep have long been farmed as dual-purpose stock, prized for their meat as well as for their fleece. Further grazing was to be found across the rich and fertile Romney Marsh and it is from the rough-pasture-grazing animals of this area that the world's best-known sheep variety can trace its descent. The chalk heaths along the Greensand Ridge offered opportunities for mixed farms and saw the establishment of an abundance of fruit orchards and nut plats, whereas in the close-guarded, inaccessible depths of the woody Weald, many farmers traditionally aimed at simple self-sufficiency, availing themselves of the free, natural fodder of the native broadleaves to feed their pigs whilst producing just enough cereal and crops to sustain their families and livestock with less regard to marketable goods and profit margins.

From the 1500s, a burgeoning national population and the long reach of London fuelled two centuries of increasing expansion and specialisation in Kent's food production. In addition, thousands of Flemish and European refugees fleeing the religious persecutions of the continental Reformation arrived in London. These 'strangers' were actively encouraged to settle outside the capital and, consequently, made their way into Essex and Kent, where particularly strong communities grew up around Sandwich and Canterbury. With these in-comers came a wealth of new horticultural knowledge and skill, contributing to the phenomenally successful development of market gardening in the region, which was sustained by a steady influx of plant specimens from across the ever-expanding colonies of the New World.

Innovation in Victorian engineering and the cutting of the railways suddenly opened up previously inaccessible areas, giving the county's producers access to ever-wider markets and seemingly limitless opportunity; by the turn of the twentieth century, fruit production occupied almost 50,000 acres of Kentish soil and Kent fruits were being sent, through London, to every corner of the country. The security provided by this industry encouraged some Kent farmers to try more risky ventures such as tomatoes, salad vegetables, dairying and, of course, hops. When the worldwide agricultural depression of the 1870s hit England, Kent's farmers were forced to adapt and diversify, taking almost half the county's arable land out of cultivation and increasing permanent pasture by over 100, 000 acres[1]. As the agricultural slump dragged on into the twentieth century, many of Kent's farmers struggled with the impact of foreign competition, for which they were ill-prepared. Government intervention aimed at supporting domestic farming was implemented with the Corn Production Act of 1917 and this support was continued with a series of subsidies and price guarantees throughout the 1920s and 1930s.

In the aftermath of the First World War, when the great estates were broken up and dispersed, many of Kent's tenant farmers were able to buy their own farms, ushering in a new a new phase in rural social history as a generation of farm labouring families

stepped across a social divide to establish themselves and seize their independence. Many of those families continue to farm those holdings to this day. The interwar period saw great technical innovation and scientific research – in particular, at the East Malling Research Station – from which most of Kent's farmers would benefit and profit. The 'Plough Up' scheme and famous 'Dig for Victory' campaign, both aimed at managing the colossal demands upon the country's resources resulting from the Second World War, made significant changes to Kent's farmed landscape in bringing more acreage into arable production. Perhaps equally significant during this period was an increased public awareness of the role of British farmers and a heightened appreciation for the value of their contribution to the national economy.

National prosperity in the 1950s saw real rises in farming income, and the period is marked, across Kent, by an increase in soft fruit production and a revitalisation of market gardening. Membership of the European Union would support this buoyancy but, as some farms expanded, so others were swallowed up and the nature of farming began to change as traditional, independent and family-run mixed farms gave way to large-scale, professionally managed farming enterprises. The last quarter of the twentieth century saw dramatic cuts to farming income, resulting from a combination of international pressures and the ever-increasing domination of the British supermarkets. It is too early to assess the effects of Brexit, but many, including the National Farmers' Union, recognise this as an opportunity for Britain to reduce its dependency upon imported indigenous foodstuffs, many of which 'could be grown in the UK'[2], and rediscover the varied and diverse cornucopia of homegrown comestibles.

Hops, Beer and Brewing;
Wines and Spirits

HOPS AND HOP GARDENS

'Hop', from 'hoppan' (Old English): 'to climb'; *Humulus lupulus* (Latin): 'little wolf' – a descriptive reference to its rampant growth.

Culpeper ascribes a wealth of benefits to this humble hedgerow vine, including hormonal rebalancing, cleansing of the blood and the expulsion of parasites and poisons from the body. Traditionally used as a tonic to settle nervous disorders and anxiety, as a diuretic or cure for stomach complaints, the hop flower (or bract) contains lupulin, a highly sedative oil which has antibacterial properties and can also be used in the treatment of neuralgia, bruising and rheumatism. Modern chemical researchers have discovered that the hop has stimulating effects on the skin and hair, making it a key ingredient in many anti-dandruff and hair-loss prevention shampoos. The hop is nothing if not versatile, but its true claim to fame, first recorded in the annals of the abbeys of Charlemagne, and the reason this rampant rambler is prized so highly across the globe, is its ancient association with the brewing of beer.

According to the British Hop Association, it is the mild maritime climate, even rainfall and fertile soils in Kent that make for perfect hop-growing conditions, and it is this 'terroir' that creates the delicate and distinctive, uniquely British, hop flavour. Take a walk along any Kent hedgerow in August and you will see just how tenacious and prolific the wild 'little wolf' can be, but don't be fooled by this show of bravado: this is a sensitive plant and its susceptibility to pests and diseases means that its successful cultivation requires the application of science and sound farming practices. Little wonder, then, that England's first hop garden was established in Kent, where wealthy farmers and landowners – many of whom had made their fortune from the local wool industry – had the necessary capital for specialist equipment and research into new techniques[3]. In his celebrated *Perfite Platforme of a Hoppe Garden*, published in 1574, Ashford gentleman Reginald Scot gave us the first practical treatise on hop cultivation. At this time, there were two popular growing systems: mounding, which required the staking of the vines with poles that were removed each year, and stringing, which called for the erection of permanent string or twine frames, attended by stilt-walking workers. This latter was the method with which Kent farmers and hop pickers would become familiar. Those early farming experiments paid off and, by the end of the sixteenth century, Kent was producing one third of all England's hops.

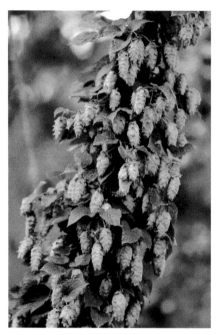

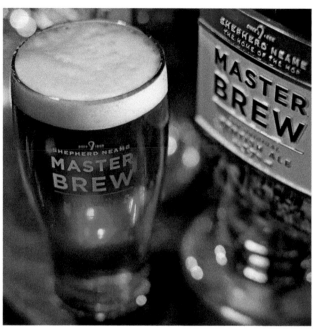

Above left: (Photograph Alison Capper)

Above right: Shepherd Neame's famous Master Brew – a thoroughly Kentish beer. (Photograph Shepherd Neame)

Left: *A Perfite Platforme of a Hoppe Garden*, the first treatise on hop cultivation, was published by Ashford gentleman Reginald Scot in 1574.

A Perfite platforme

of a Hoppe Garden,
and neceſſarie Inſtructions for the
making and mayntenaunce thereof,
with notes and rules for reformation
of all abuſes, commonly practiſed
therein, very neceſſarie and
expedient for all men
to haue, which in any
wiſe haue to doe
with Hops.

Nowe newly corrected and augmented
By Reynolde Scot.

Prouerbs.11.
Who ſo laboureth after goodneſſe, findeth his deſire.

Sapien.7.
Wiſedome is nymbler than all nymble things.
She goeth thorough and attayneth to all things.

❦ Imprinted at London by Henrie
Denham, dwelling in Pater noster
Rovve, at the Signe of
the Starre.
1576.

Cum priuilegio ad imprimendum ſolum.

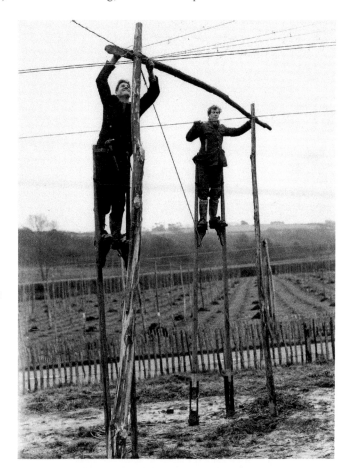

Right: Stilt-walking workers were once a familiar sight in Kent's many hop gardens. (Photograph Stocks Farm)

Below: For many families – and particularly London families – 'hopping down in Kent' became an annual summer holiday fixture. (Photograph Shepherd Neame)

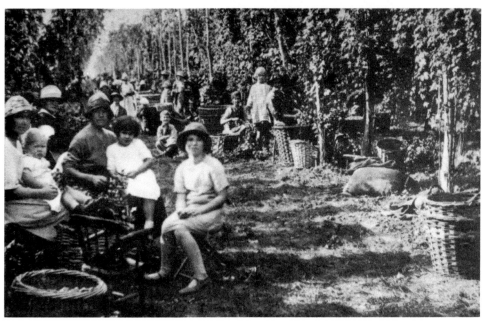

By the 1800s, some 77,000 acres of the county were given over to the crop and the popular 'hopping down in Kent' excursions from London became an annual summer fixture for hundreds of the city's families. During the same period, the humble hop was often a hot topic of parliamentary debate as increasing tax burdens began to force reductions in domestic hop production and threatened to cripple the industry. At one stage, a contingent of Kent farmers, who had gathered at Staplehurst (almost the centre of the county), converged on Westminster to present Parliament with a petition against the imposition of further excise duty on their crop and livelihoods. There was also a great deal of rivalry among growers in other areas – particularly in the neighbouring county of Sussex – as Kent hops always commanded a higher price at market than their competitors, apparently regardless of variety or comparable quality. Gradually, brewers began to turn to imported hops and so began a rapid decline in domestic production; by the time of the First World War, Kent hop acreage, at 32,000, was less than half what it had been a century earlier. However, today, Kent is once again home to flourishing hop gardens, with around 3,000 acres currently in cultivation, and is also home to the National Hop Collection at Queen Court Farm, a research centre where over 200 varieties of hops are preserved and research is carried out into hop husbandry and new breeds.

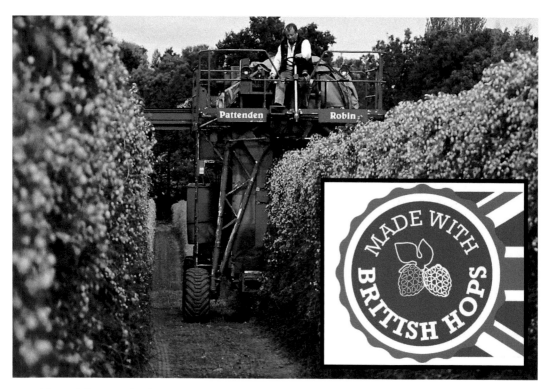

Above: (Photograph Alison Capper)

Inset: British Hop Association.

OAST HOUSES

If there is one iconic image of Kentish vernacular architecture, it is the oast house. Designed for the most efficient drying of hops, the typical oast, kiln or – in the Kentish dialect – *kell* is a common sight across the county and a true symbol of home to Kent folk. There is evidence that these distinctive, characterful structures were being built from as early as the 1570s, but the earliest surviving purpose-built oast, at Little Golford, Cranbrook, is thought to date from the late seventeenth century. A typical oast house generally incorporated a rectangular stowage area, with a large kiln and drying chamber in a roundel section at one end (although these chambers were also sometimes built square). A fire at the base of the kiln produced hot air that rose through the thin, latticed drying floors above, and out through the roof cowl, which was designed to move with the wind to ensure a good draught. Freshly picked hops were spread across the drying floor as soon as possible after harvesting to begin the twelve-hour drying process, which reduced their moisture content from

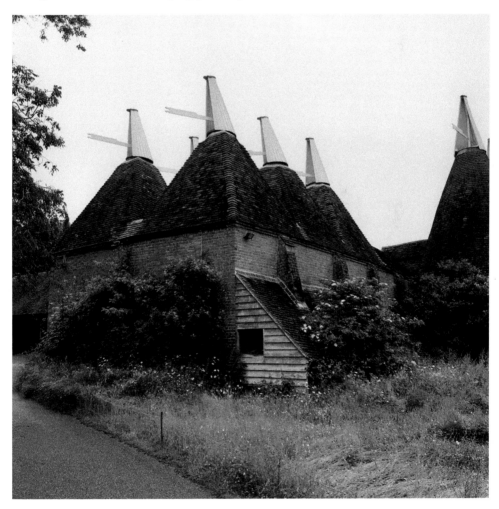

around 80 per cent to below 10 per cent. Once the fire was out, a scuppet (a wooden, short-handled, shovel-like tool with a hessian or canvas scoop) was used to transfer the dried hops to the stowage floor where they would cool; from here, the hops were packed into pockets, each containing 150 imperial bushels (64 kg) and clearly marked with the grower's name and address before being sent to market.

In some cases, existing barns or other buildings were transformed into functional oast houses by the addition of a kiln and some clever structural re-engineering; the oast at Great Dixter, built in the 1890s onto the end of the ancient Great Barn, is an example of this. By contrast, the Hop Farm at Beltring – with twenty-eight kilns, the largest collection of oast houses in the world – is a purpose-built complex that was being developed from the Tudor period well into the middle of the 1900s.

Collecting pokes. (Photograph Stocks Farm)

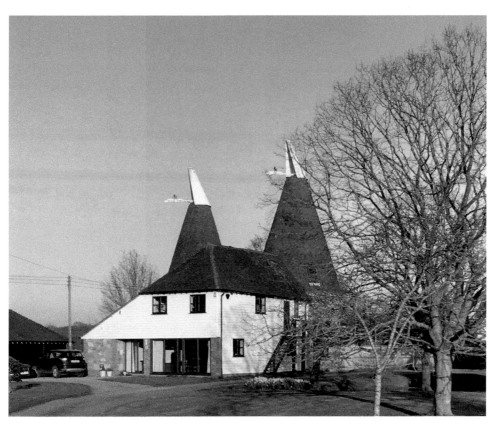

Many oast houses have now been converted into characterful accommodation.

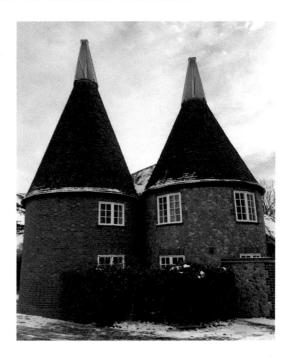

BEER AND BREWING

In Britain – and in Kent in particular – we know that hops have been cultivated commercially for brewing since around 1600 but there is evidence to show that Kent folk had a taste for beer centuries before this. Traces discovered in the hold of the Graveney Boat, a Saxon cargo vessel uncovered in the Thames Estuary between Faversham and Whitstable in 1970, suggest that hops were being shipped into the county as early as the 900s. During the mid-1300s, Edward III, whose wife, Philippa, was from Hainault in the Netherlands, encouraged the immigration of skilled Flemish weavers, many of whom settled in Kent. With the Belgians came beer and it seems improbable that they would not have introduced the locals to their national beverage; at the same time, the European monastic tradition of brewing was being disseminated across the county's many religious houses. Even if hops were not being cultivated for brewing at this time, we know that in Faversham, by the late 1300s, the sale of locally produced beer was being regulated by the Town Presenters. However, in the same town, there were over eighty alewives making a healthy income from their homebrewed ale – a very different drink from the new, bitter, hopped beer – and there is no certain evidence that beer was, at this time, a particularly popular drink for the masses. By the sixteenth century, the situation was very different…

Writing in the 1540s, Dr Andrew Boorde (by all accounts a rather eccentric and colourful character) gave a scathing description of beer, which he refers to as a recent addition to the English diet, imported from Holland:

> 'Bere', he writes, 'is made of malte, of hopes, and water: it is a natural drynke for a Dutche man. And nowe of late days it is moche used in Englande to the detryment of many Englyssche men; specially it kylleth them the which be troubled with the colycke, and the stone, & the strangulion; for the drynke is a cold drynke; yet it doth make a man fat, and doth inflate the bely, as it doth appere by the Dutche mens faces & belyes.'[4]

By the time Boorde wrote this, the English love affair with beer was well and truly established and, in Faversham, William Castlock and his son were running a beer import-export business that had grown up in association with the town's abbey; by 1570, the family-owned premises at No. 18 Court Street. An independent brewery was established here in 1698 and continues to manufacture beer to this day, making Shepherd Neame 'Britain's Oldest Brewery'; in fact, it is believed that there was ale in commercial production at its Faversham site as early as 1573. The Shepherd family took the reins in the 1730s and introduced great improvements and innovations to the manufacturing process, including the introduction, in 1789, of the brewery's first steam engine. This progressive move set the brewery apart from its main competitors, making it the only one outside the capital to utilise steam power and signalling a bold name change for the 'Faversham Steam Brewery'. Growth and improvement continued throughout the next century and, in 1864, the Shepherd family's heirs were joined by Percy Beale Neame, a young, local hop farmer. Percy's arrival coincided with the construction of the tower brewhouse, situated behind the elegant façade of Court Street, which remains in use to this day. By the end of the century, Percy's three sons were running the business, and the family is still very much at its helm.

Right: No. 18 Court Street, Faversham. The Castlock family ran a beer import-export business from these premises in association with the town's abbey during the 1500s.

Below: Shepherd Neame premises, Court Street, Faversham. (Photograph Shepherd Neame)

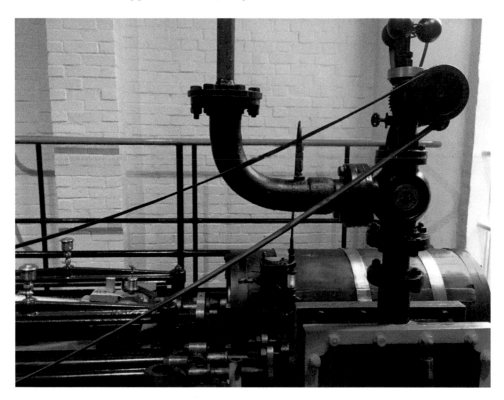

Above: The installation of the first Sun and Planet steam engine in 1789 prompted a name change for what now became known as the 'Faversham Steam Brewery'.

Left: The Victorian Tower Brewhouse is still in daily use.

An astonishing 60 million pints of Kentish beer are produced at the Shepherd Neame brewery every year, created from locally grown hop varieties such as Challenger, Fuggles, East Kent Goldings, Target and Admiral. The raw ingredients of beer are few and simple: water, grain, yeast and hops. Shepherd Neame brewers use water – referred to as 'liquor' – drawn from their own artesian well, sunk 90 metres into the Kent chalk, beneath the brewhouse, while their six strains of yeast (most UK brewers use only two) are carefully managed and preserved at the National Collection of Yeast Cultures. The basis of all beers is malt – grain that has been soaked to precipitate germination, then kiln dried to specification. It is the degree to which the grain is malted that will determine the final colour and flavour of the beer. At Shepherd Neame, only British barley malt is used, delivered daily and ground in the brewery's mill.

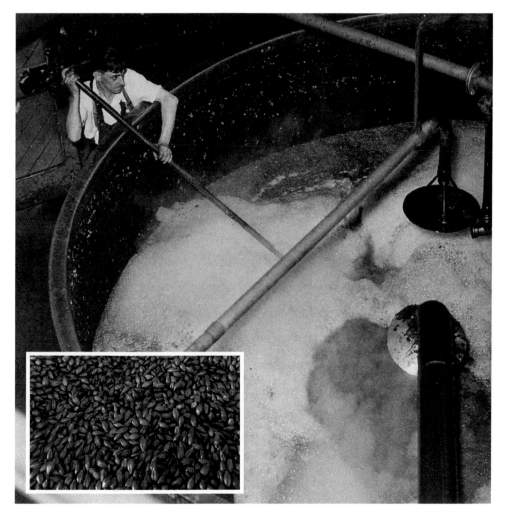

Above: Bill Epps, in 1946, stirring the water and barley 'mash'. (Photograph Shepherd Neame)

Inset: The malt roast determines much of the flavour and colour of beer and ale.

The label is exported all over the world but there is a strong sense of local heritage in the brewing and branding of Shepherd Neame beers: their flagship ale, Master Brew, an entirely Kentish concoction made using Kent hops and barley, is known as 'the original Kentish ale'. The fiftieth anniversary of the Battle of Britain, fought by 'the Few' directly above the Kentish coast and fields – and above the Shepherd Neame brewery itself – was marked by the launch of their Spitfire range with Spitfire Amber Ale in 1990. Bishop's Finger, launched in 1958 to celebrate the end of rationing, is named in reference to the finger-shaped signposts that guided pilgrims to Becket's tomb at Canterbury. Its production is governed by a charter that states the award-winning beer (which can only be produced by the Head Brewer on a Friday!) must be brewed from Kentish hops and barley and water from the brewery's well. Its distinct, uniquely Kentish provenance earned this beer, like the brewery's tercentenary '1698' celebration ale, European Union Protected Geographical Indication status. Ever an innovative bunch, Shepherd Neame became the UK's first brewer of lagers in the 1960s and their current expansive range includes Spitfire and Whitstable Bay lagers as well as their Bear Island brews; these, made with imported American hops, are named for the 'one bear and his keeper' once landed from a cargo ship at the little island in the Creek at Faversham, where the brewery has stood for half a millennium.

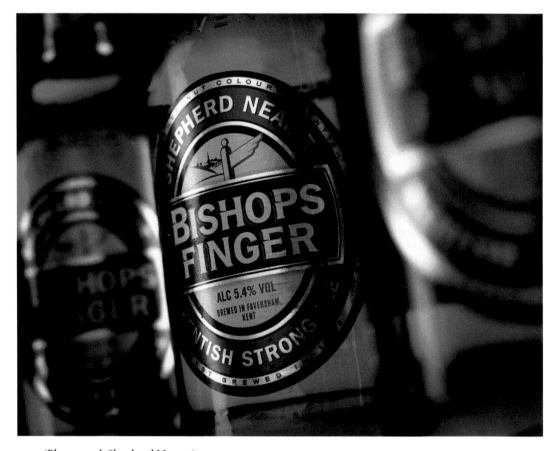

(Photograph Shepherd Neame)

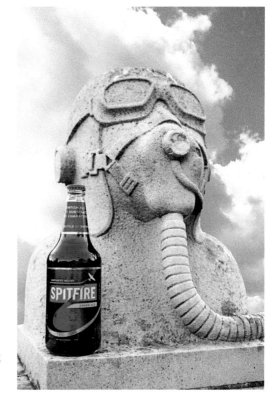

Right: (Photograph Shepherd Neame)

Below: Charlie, Shepherd Neame's last working dray horse, pictured in 1968. (Photograph Shepherd Neame)

(Photograph Shepherd Neame)

KENTISH CIDER

In a protected enclosure abutting the city wall, the brethren of Canterbury's medieval Christchurch Priory established and nurtured a 'Pomarium'. Undoubtedly, the apples produced in this orchard were prized as fresh fruit and for the sweet, perfumed flavour they could impart to cooked and preserved delicacies but the monks of Canterbury – like their counterparts across Christendom – worked a little magic with these autumn gems: they made cider. In post-Conquest documentary records, we see evidence that many monastic houses were pressing, and trading in, cider on an industrial scale, selling to the local population and turning a handsome profit; however, it is likely that the locals would have discovered the wonder that is cider centuries before Duke William was blown into Pevensey Bay.

Traditionally, the presses of Kent were renowned for their strong, dry, spiced cider and, after Richard Harris' orchards were established at Teynham in the 1530s, the county's producers experienced something of a taste revolution. New varieties of apples, many imported from France and Holland, were propagated by local growers as apple

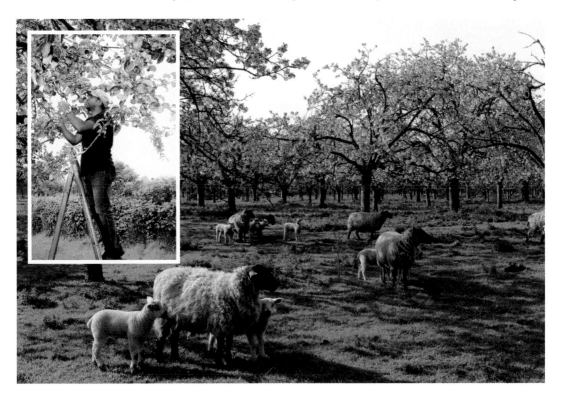

Above: (Photograph Pippa Palmar)

Inset: (Photograph Flashbang Photography)

orchards across the region were developed and enlarged. Apple cider soon became a staple element of the rural family's diet, and agricultural workers would often receive a fortifying daily allowance in lieu of a portion of their wage. In his observations of Kent agriculture, written at the end of the eighteenth century, John Boys lists the 'favourite sorts of apples for cyder' in the county as 'the Golden Rennet, Sharp Russet, Golden Mundy, Kernel-permain, Stire-apple, Risemary, Farley-pippin, and Red Streak'[5].

By the twentieth century, the myriad small-scale, farmhouse cidermakers like those encountered by John Boys had become overshadowed by a few large firms, mass-producing under factory conditions, but, in recent years, a quiet revolution has been gathering pace and there is now a strong, renewed interest in the 'real' cider of the country farmhouse, which simply cannot be replicated on an industrial scale. Faversham couple Mark and Serena Henderson established the CAMRA award-winning Kent Cider Company just over a decade ago. They produce unique and seasonal craft ciders to suit all tastes, from their traditional, strong, dry, still cider, 'Russet', to the exciting contemporary flavours – including rhubarb, elderflower and toffee apple – of their 'Henderson' range. The Hendersons pride themselves on their Kent heritage and the local provenance of their raw ingredients: they use fruit sourced from within a close radius of Faversham and some of their ingredients, such as the nettles in their 'Unity' cider, are wild foraged from their own orchards. At Biddenden

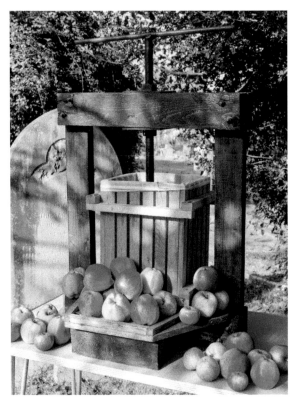

Left: October apples ready for the press. (Photograph Graham Haskett)

Below: Some of the Kent Cider Company's range. (Photograph Kent Cider Company)

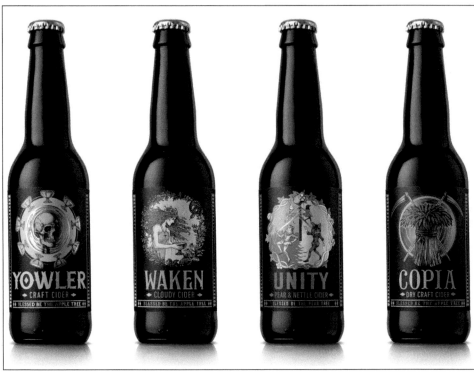

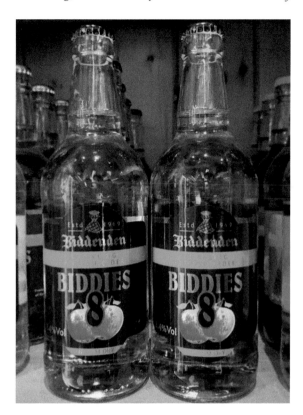

'Biddies' cider, produced at the Biddenden Vineyards, is bottle fermented. (Photograph Biddenden Vineyards)

Vineyards, they also produce a traditional still, Kent cider, pressed from their own, home-grown and other locally sourced culinary and dessert apples. Perhaps it is little wonder that this vintner's cider is described as having a more 'wine-like style': their 'Biddies' range and 'Biddenden Sparkling Ciders' – including their exclusive, rosé blush 'Red Love® Sparkling Cider' – are bottle fermented by the same method used to produce Champagne.

LAMB'S WOOL RECIPE

Lamb's Wool is an ancient recipe for warmed, spiced cider or ale. Some claim that the truly traditional recipe calls for wild crab apples, which burst into little fluffy clouds of apple-y 'wool' when they are cooked but, if crab apples are not available, it is possible to make a deliciously spiced, warming drink using cooked apple purée.

Pour equal parts cider or ale and apple juice into a large pan; you can adjust the alcoholic content or even make a completely alcohol-free version with some very dry apple juice. Throw in four to six cinnamon sticks and a handful of cloves, plus four to six cardamom pods, and add slices of fresh ginger and a few peppercorns if you like a little fiery heat. Peel some small apples (or crab apples if you can get them) or wash them and score the skins, then drop these into the pan and cook this mixture until the apple flesh becomes fluffy or 'woolly'. Add brown sugar or honey to taste and serve

piping hot. If using cooked apple purée, put this in the bottom of the serving jug or stir through the warm ale or cider before serving. Just the thing for a yowling or a Bonfire Night treat!

THE ENGLISH VINE

The Romans knew a thing or two about wine and we know that they cultivated vines in England during their occupation of the British Isles. This was a period of localised climatic warming, sometimes referred to as the Roman Warm Period, in Europe and the North Atlantic region, which produced weather patterns and average temperatures highly conducive to the cultivation of vines[6]. Although no direct archaeological evidence of Roman era commercial vineyards has yet been discovered in Kent, it is highly probable that here, as elsewhere across the empire, the vine was grown in the gardens of both large villas and smaller dwellings alike for domestic wine production; our Romano-British forebears might well have made house wine for daily consumption in much the same way as their medieval descendants brewed ale. Certainly, vines are easily grown, and the modern Kent climate – very similar to conditions during the Roman occupation – appears to favour their cultivation.

Fifty years ago, Biddenden apple farmer's wife, Mrs Barnes, was inspired by a radio programme to plant a little area of vines; in the 1960s, there was a move towards re-establishing vineyards across Britain and, in a time of declining fruit prices, the Barnes family was looking to diversify. From those first, tentative steps, the Biddenden Vineyards have evolved and now cover an area of twenty-three acres. Increasing the

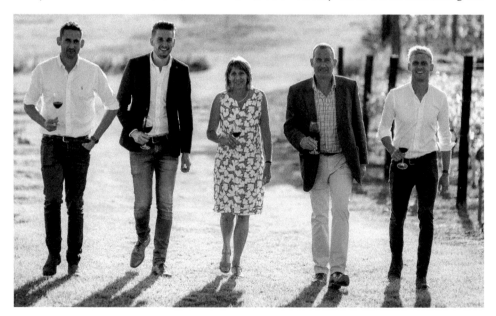

Kent vintners Sam, Tom, Sally, Julian and Will Barnes produce 80,000 bottles of Kent wine each year. (Photograph Biddenden Vineyards)

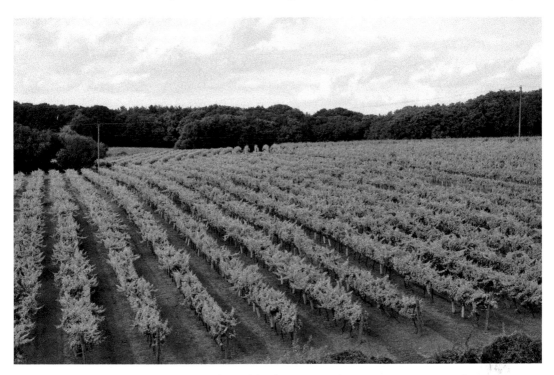

From a few experimental vines, the Biddenden Vineyards now cover an area of 23 acres. (Photograph Biddenden Vineyards)

(Photograph Biddenden Vineyards)

scale of their production has required experimentation and expansion; a sandy loam and south-facing slope create the perfect microclimate for French and German grape varieties such as Ortega, the vineyard's signature variety, and Pinot Noir, and the single estate vineyard now supports eleven grape varieties, which are transformed annually into 80,000 bottles of award-winning red, rosé, white and sparkling wines. However, this leading light in the Kent wine industry – the 'original Kent vineyard' – remains very much in the hands of the family that created it, with a third generation of Biddenden vintners now taking the helm.

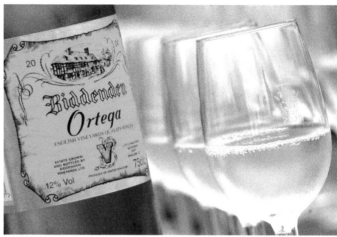

Above left: (Photograph Biddenden Vineyards)

Above right: Biddenden Ortega – the vineyard's signature variety. (Photograph Biddenden Vineyards)

Left: (Photograph Biddenden Vineyards)

MEAD

When Beowulf entered the mead hall of Heorot, he wasn't offered a pint of beer; in Hrothgar's house they drank mead. The Brythonic poet Aneirin described another mead hall in seventh-century Edinburgh while his contemporary Taliesin paid homage to the legendary libation in his sixth-century *Song of Mead*. In fact, mead has been enjoyed, the world over, as far and wide as history can take us. Traces of mead over 9,000 years old have been discovered in Chinese archaeological excavations and there is evidence that the gilded liquor has been savoured in Europe for some 5,000 years.

Made by fermenting honey in a similar way to that in which grapes are fermented to produce wine, mead – or 'honey wine' – still has a strong and loyal following and this earliest of drinks has lately enjoyed something of a renaissance, thanks, in part, to the recent fascination with all things Norse. In Kent, one winemaker is completely reinventing English honey wine for the twenty-first century: 'Marourde, the world's oldest new drink', is a unique, modern take on this ancient, traditional beverage. The idea of Will Boscawen, whose family has farmed at Mereworth for 250 years, emerged when he began contemplating life before wine – what did people drink before the birth of the vintner? – and discovered one unequivocal answer to his question: mead. This, perhaps more than any other, is our national drink; there are references to mead in the etymology of so many of our Anglo-Saxon place names and in our historic vernacular

Mead – possibly the world's oldest alcoholic drink – is still produced in the Kent countryside.

literature – and isn't there just something rather romantic about a concoction created from the wildflower honey of an English meadow?

What Will produces is a far cry from the syrupy, sweet mead familiar to our medieval forebears. 'Marourde Spritz' is a crisp, medium-dry, sparkling honey wine, with a fresh flavour and only a fraction of the alcohol one might expect from a more traditional version. According to Will, mead is a phenomenally versatile product and tremendously accommodating in terms of experimenting with flavours and alcoholic content. However, its fermentation can be difficult to master, requiring a great level of skill and patience. The area around Mereworth is still heavily wooded and this dense tree cover provides varied and plentiful nutrition for the seventy beehives maintained around the farm. This, coupled with the nectar harvest from the Mereworth soft fruit fields, goes to make the honey destined for 'Marourde'. Every different honey harvest produces its own unique flavour so, for example, whereas a clover honey mead might be mild and sweet, a bramble honey mead would have a far more robust and spicy natural flavour. Since 2019, the honey wine has been produced at the medieval Brewer's Hall Oast in Mereworth, where it is fermented in oak barrels for warmth and subtle sweetness. The flavour of the rosé variety is enhanced by the addition of elderflowers and elderberries – a choice which might have been influenced by the family name: the Cornish term for the elder tree is 'skaw' and Boscawen means 'House of the Elder Tree'.

GIN

The precise origins of gin are impossible to determine but it has been a popular British tipple since at least the 1600s. Developed from the Dutch and Belgian medicinal tonic, *jenever*, gin became especially fashionable here after the Protestant government of William of Orange imposed heavy taxes and restrictions upon the import of Catholic French brandy at the end of the seventeenth century. And it is probable that English soldiers serving in Flemish Antwerp against the Spanish in the 1580s were bolstering their own spirits with a swig or two of 'Dutch Courage' before ploughing into battle.

Whatever the nuances of its journey, by the 1700s gin had well and truly arrived in Britain, was blazing a trail through the social habits of the Great British public and was definitely here to stay. At the time, lax licensing laws and the relatively inexpensive raw ingredients used to make gin meant that pretty much anyone could turn their hand to a bit of distillation. And many did just that – so much so, in fact, that during the first half of the eighteenth century, the country would succumb to the 'Gin Craze', which saw annual consumption levels of around 10 litres (just over 2 gallons) of gin per person! Parliament churned out legislation throughout the 1730s, 1740s and 1750s, in increasingly desperate attempts to stem the tide of dissolution and social havoc being caused by the seemingly limitless production and consumption of gin. Social commentator Daniel Defoe referred to gin as the 'a certain new distill'd Water call'd Geneva' designed by distillers to hit the palate, but not the pocket, of 'the poor soldier'[7]. Anti-gin campaigners linked the 'cursed Fiend' to rising crime rates and the deterioration of public health and morality, while Hogarth's famous depiction of the

ruined 'Gin Lane', published in 1751, captures in vivid detail the horrors inflicted by the 'deadly Draught'. When legislation prohibited the distillation and sale of gin, a sinister bootleg trade in dangerous and poisonous liquor began to flourish. However, a series of poor harvests and a continuing increase in the national population pushed grain prices ever higher and this, coupled with the effects of high taxation imposed by the 1751 Gin Act, effectively stifled the craze by the 1760s. But it was not long before

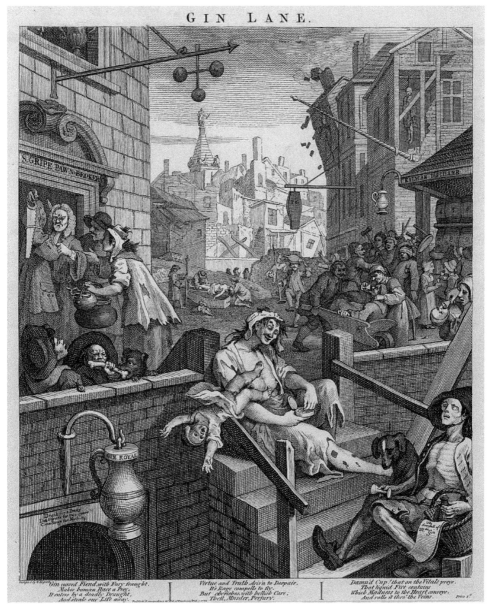

Hogarth's *Gin Lane*, 1751, clearly illustrated the dire effects of what many anti-gin campaigners referred to as 'the cursed fiend'.

the emergence of a new sort of drinking house in the Victorian era would reignite the nation's love affair with this treacherous tipple.

By the 1830s the 'gaudily fitted up bars' of the 'modern gin-palaces'[8] were pulling in customers from every London street, each desperate to take a 'drain'. In his *Sketches by Boz*, in 1836, Charles Dickens gave a colourful and inviting description of one such place on the corner of Tottenham Court Road:

> 'All is light and brilliancy. The hum of many voices issues from that splendid gin shop...
> with the fantastically ornamented parapet, the illuminated clock, the plate-glass
> windows surrounded by stucco rosettes, and its profusion of gas-lights in richly-gilt
> burners, is perfectly dazzling when contrasted with the darkness and dirt we have just
> left ... Beyond the bar is a lofty and spacious saloon, full of ... enticing vessels, with
> a gallery running round it, equally well furnished. On the counter, in addition to the
> usual spirit apparatus, are two or three little baskets of cakes and biscuits...'[9]

In the 1770s, a young man from Kent spent some years in Holland, researching and studying the distillation and production of gin with the intention of setting himself up in the industry in his home town of Maidstone. His impressive knowledge and confident manner convinced the British government that, by producing a safe, home-grown spirit, under proper regulations and government-licenced control, he could eliminate some of the dangers associated with gin as well as eradicate the illicit trade in Geneva smuggled from the continent. George Bishop's gin distillery, built in Bank Street, was up and running by the 1780s and, within twenty years, was renowned across Europe for the quality of its produce: the superior Maidstone Gin was of extra strength and, at one time, Bishop's distillery was producing thousands of gallons of 'Maidstone Hollands', a whisky-based Geneva spirit, per week. Sadly, the success of his business did not long survive George's death in 1793 and his family had closed the factory before 1820, but Bishop's reputation, and the association of Maidstone with the production of high-quality gin, would pave the way for the on success of a fellow Kent entrepreneur.

Nearly forty years later, another creative Kent man, Thomas Grant, having established the county town's second distillery, produced a handbill advertising his new business as a worthy successor to the much-lamented Bishop's. Grant's father had been distilling at Limekiln Street in Dover since 1774, but the family had relocated to Lenham and opened their Maidstone plant in 1853. Grant's affordable spirit, of remarkable 'wholesomeness' and superior flavour, was distributed in tamper-proof corked bottles and could be supplied to the customer 'direct from the Distillery'[10]. Grant's enterprise, which would thrive and endure for over a century, finally closed its doors in the 1980s.

The twenty-first century has seen something of a gin revival in Kent, with a number of independent craft manufacturers setting up new stills across the county since the start of the century. The Anno Distillery, founded by scientists Dr Norman Reason and Dr Andy Lewis, supported by their small, dedicated team, has grown from a modest gin still in a Maidstone domestic kitchen to a multi-award-winning market leader. Since its

Right: © Anno Distillers

Below: Anno founders Dr Andy Lewis and
Dr Norman Reason created their first still in a
Maidstone kitchen in 2011. (Photograph Anno
Distillers)

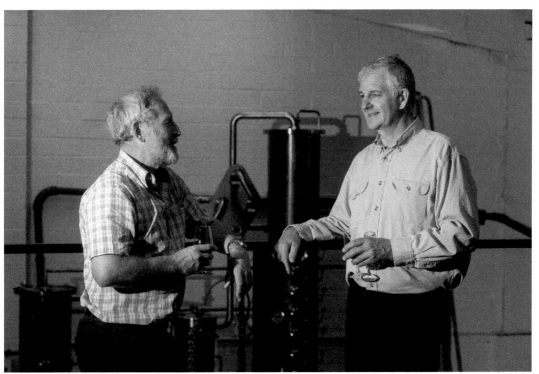

2011 inception, the distillery has relocated to larger premises in Marden, where the
company produces a range of gin-based spirits in a giant copper still they have named
'Patience'. Their 'Kent Dry Gin' can truly be said to deliver 'the flavour of Kent' as
it is infused with sweet Kent hops, samphire and a variety of local, floral botanicals
whilst their super-strength '60²' bursts with intense citrus and the woody tones of local
juniper. As well as these classic gins, they also produce several versions flavoured with

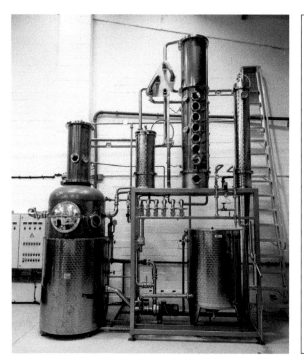

Above left: 'Patience', the Anno Distillers' enormous copper still. (Photograph Anno Distillers)

Above right: Anno's classic Kent dry gin. (Photograph Anno Distillers)

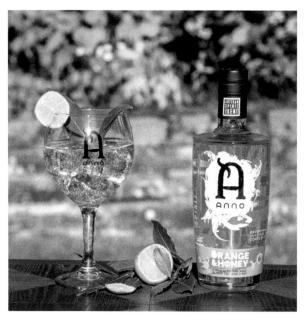

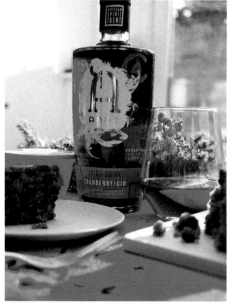

Above left: Orange and Honey Gin from Anno's flavoured range. (Photograph Anno Distillers)

Above right: Anno's Christmassy Cranberry Gin. (Photograph Anno Distillers)

Kent fruits, including a classic, ruby-coloured sloe gin – imbued with the deep, warm, berry flavours and subtle almond scent of the blackthorn fruit so abundant in the county's hedgerows – and a modern pink gin, sparkling with a fruity combination of blackberries, elderberries and strawberries grown at Clock House Farm in Coxheath.

QUEEN VICTORIA'S FAVOURITE TIPPLE

When he received a sample of the little-known Morello cherry from a local farmer, Thomas Grant, Maidstone's premier gin distiller, was so impressed by its glorious flavour and colour that he decided to capture its essence in the way he knew best – and, in 1774, Grant's Morella Cherry Brandy was born. The exquisite liqueur was destined to become Queen Victoria's favourite tipple; the original (and aptly named) 'Queen's' sweet version was soon joined by the 'Sportsman's', a dry variety, which was instantly popular – even with Charles Dickens, whose Pickwickians sip 'with heartfelt satisfaction' a restorative glass of cherry brandy upon their arrival at Manor Farm[11]. The drink's high fruit content meant that it also gained a reputation for its medicinal quality and lucky patients at St Thomas' and other hospitals were routinely offered a tot of Grant's 'best Morella' as a health tonic. By the 1890s, Grant owned orchards of around 20,000 Morello cherry trees in and around Maidstone and Lenham. Today, these orchards are celebrated at the Kent Orchards' Cherry Downs site, at Warren Street. This new, small area of Morello orchard contains twenty-eight cherry trees (of both sour and sweet varieties) and a mixture of plums, apples and pears; it is the perfect place to enjoy a spring picnic under the blossom – and maybe raise a glass to Mr Grant.

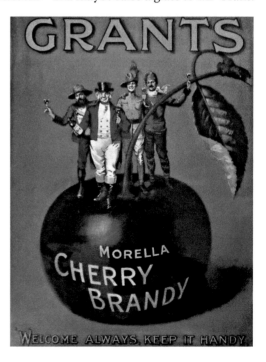

Grant's Morella Cherry Brandy would become a firm favourite with Queen Victoria and her devoted public.

Orchard Fruits, Soft Fruits and Nuts

APPLES – *MALUS DOMESTICA*

The warm climate and well-drained soils of the Kent Downs and Weald provide comfortable growing grounds for some of Britain's most prized orchard fruits and, with over 7,000 known unique varieties, the apple is, undoubtedly, one of the most popular. While wild crab apples (*Malus sylvestris*) have been a feature of the British landscape since at least the Neolithic period, the cultivated apple is a relative newcomer. Infinitely versatile, it is easy to imagine how appealing these brightly coloured, sweet-tasting cultivated fruits might have been when they first arrived on Kent shores, at the end of their journey along the Silk Roads from China; easy, too, to understand how they might have earned the title 'fruit of the gods' and, in the shelter of Kentish hedgerows, it is little wonder that the cultivated apple began to thrive.

Originating in central Asia, the wild apple, *Malus sieversii*, has been proven to be the ancestor of most varieties of *Malus domestica*, our modern eating and culinary apples. This medium-sized, deciduous tree is native to the mountainous regions of Kazakhstan and is celebrated in the name of the country's former capital, Almaty, which is derived from the Kazakh word *alma*, meaning 'apple'. It is the larger size and mild flavour of this tree's lime and ruby bicoloured fruit that sets it apart from that of other wild species, which tend to be small and bitter tasting. Sixty million years of evolution have allowed *Malus sieversii* to develop unparalleled disease resistance as well as the resilience to withstand – and even thrive in – the punishing conditions of Kazakhstan's extreme continental climate, making this species a key component in ongoing research into the development of more hardy domestic apple varieties.

Although there is no definitive evidence of the date of the first arrival of the domestic apple in the British Isles, it would have been commonplace to the Romans, who are known to have cultivated several types for eating when they arrived here in 43; the

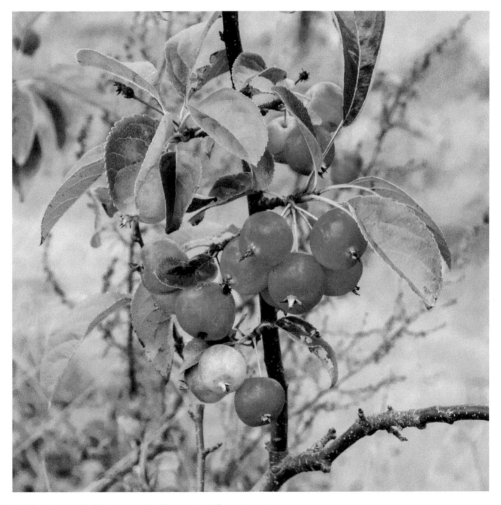

Malus sieversii. (Photograph Flemming Thorninger)

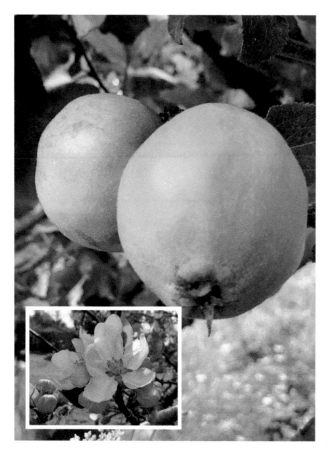

Malus domestica 'Flower of Kent'.

Mural decorations found in Roman villas – for example in Rome and Pompeii – often depict abundant gardens containing fruit trees, demonstrating the Romans' affection for orchard fruits.

pagan Roman goddess, Pomona – named for *pomum*, or orchard fruit – was venerated as the deity of abundance and represented by the symbol of the apple. It would not have been unusual for the wealthy Romano-British owner of a luxurious Kent villa – like one of those at Lullingstone, Folkestone or Crofton, for example – to have included a number of fruit trees in his garden planting scheme. We know that the Benedictine brethren at Canterbury were growing orchards fruits, including apples, in the 1100s, when the great Eadwine Psalter was compiled, but the oldest known reference to a cultivated, named variety of apple in the British Isles occurs in a document from 1204, recording a payment of two hundred Winter Pearmain, in Norfolk. The cultivar known (and held at the National Collection) today as 'Old Pearmain' is unlikely to be exactly the same as the variety recorded in the thirteenth century, and it is probable that we have lost knowledge of that particular fruit, but it seems reasonable to surmise that there might be similarities between the two. Another once-popular apple, the Costard – first referenced in 1297 – is similarly elusive when it comes to definitive identification. It is likely that the terms 'pearmain' and 'costard' refer to types of fruit, rather than single varieties, and these two were possibly introduced to England by the apple-loving Normans, meaning that they would likely have entered the British Isles through the Channel gateway of Kent. Both these early named apples appear to have been popular – the Pearmain particularly for cider-making and the Costard for cooking – throughout the medieval period, but it seems that the Costard was either not grown widely or had already faded into legend by the seventeenth century when renowned Hampshire agriculturalist John Worlidge wrote in his *Treatise on Cider*, in 1678, that he was not acquainted with them, though he knew them to be 'apples of esteem'; perhaps he might have found them if he had ventured into Kent…

In 1533, under the auspices of Henry VIII, local man Richard Harris,

> 'obtained 105 acres of good ground in Tenham [Teynham], then called the Brennet, which he divided into ten parcels, and with great care, good choise, and no small labour and cost, brought plantes from beyonde the Seas, and furnished this ground with … the sweet Cherrie, the temperate pipyn, and the golden Renate'[12]

in order to create a series of royal fruit orchards. So successful was Harris' venture that the East Kent fruit belt rapidly expanded and, very soon, there were fruit farmers across the entire county, fulfilling the ever-growing demand from London, as the Tudor capital's numbers – and appetites – began to swell. By the eighteenth century, the county's fruit farmers were transporting their produce the length and breadth of the country. In response to strong competition from French and even American imported fruit, and in the wake of the agricultural depression that devastated Europe from the 1870s, Kent's fruit farms were overhauled and modernised. This resulted in further expansion and the area of Kent land devoted to fruit production had been increased by as much as 150 per cent to around 25,000 acres by the turn of the twentieth century.

Many once-common apples are largely forgotten and might well be lost, but the enormous diversity of apples available for cultivation is represented at the National Fruit Collection at Brogdale, near Faversham. Here, you will find two specimens of each of

Osiers Farm, Teynham, the site of Richard Harris' original mother orchards. (Photograph Pippa Palmar)

over 2,000 different apple cultivars, carefully preserved and protected from extinction. Curated by the University of Reading and the Fruit Advisory Service Team, the collection's orchards, which are open every day to visitors, provide a valuable public green space, a haven for domestic wildlife and a significant source of nectar for local bee populations, but, more than this, they are also a living database, forming part of an international conservation programme that aims to preserve genetic diversity for research and future breeding purposes and offers professional advice to commercial growers.

We have long been told that 'an apple a day keeps the doctor away'. It seems we would be foolish to dismiss this saying as an empty proverb as generations of common practice have identified multiple health benefits associated with these modest fruits. Culpeper recommended apples for respiratory disorders such as asthma and consumption and other complaints of the lungs; he also advised the use of an apple poultice for pains in the body's side and claimed that eating apples might calm the 'hot and bilious stomach'. Traditionally, topical applications of apple preparations have been used to clean teeth, soothe sore gums, revive tired eyes and add shine to the hair. But, packed with Vitamin C and high in fibre, apples have now been scientifically proven to help lower cholesterol and prevent heart disease; the tannins they contain might help relieve the symptoms of arthritis, and the high anti-oxidant content of the humble apple skin (don't peel your fruit before you eat it!) serves to protect the body's nerve cells against degenerative conditions. As well as all of this, it is believed that apples can help protect against skin diseases, gallstones, anaemia and insomnia, confirming their well-deserved title of 'superfood'.

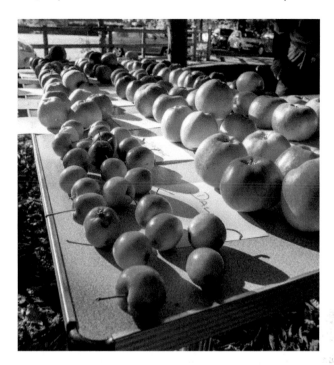

Apples of every variety on display
in Headcorn for Apple Day.
(Photograph Graham Haskett)

(Photograph Graham Haskett)

(Photograph Graham Haskett)

Keats told us that autumn was the season

'To bend with apples the moss'd cottage-trees,
And fill all fruit with ripeness to the core.'

However, not all varieties will be ready for harvesting at the same time and some fruits will store better than others over the winter. As a general guide, the earlier-ripening varieties, such as Beauty of Bath and Katy, tend not to store well, so are best eaten straight from the tree as they become ready; mid-season ripeners, such as Cox's Orange Pippin and Lord Lambourne, will keep for a few weeks in the fridge but late season varieties and many culinary apples, such as Egremont Russet and the Christmas Pippin, can be stored in a cold place right into the darkest depths of winter. The rate of ripening is determined by the development of ethylene and modern commercial producers are able to suspend the deterioration of harvested fruit by creating a carbon-dioxide-rich atmosphere for storage, meaning that we can enjoy fresh apples from the supermarkets all year round. However, traditionally, apples would have been picked then carefully wrapped and stored in apple lofts, or in the roof eaves of country houses, over the winter months.

Did you know that, since 1990, 21 October has been designated 'Apple Day'? Launched by Common Ground founders Sue Clifford, Angela King and Roger Deakin, Apple Day was conceived as an annual autumn festival, designed to promote and celebrate 'local distinctiveness', by encouraging people to reconnect with their landscape and raising awareness of the provenance of food. The first Apple Day event took place in the Covent Garden Apple Market and instantly struck a chord with the thousands who attended. Fruit nurseries, apple growers, cider makers, artists and artisans made up the forty original stallholders; within a decade, the single event had inspired 600 more and, in the thirty years since its inception, the tradition has spread all over the country. Today, Apple Day festivities encompass a vast range of activities from juicing and baking to apple identification and tree care advice, to music, plays and poetry. In Kent, there are many apple celebrations, including the Cranbrook Apple

Festivities at St Peter & St Paul, Headcorn Apple Day. (Photograph Graham Haskett)

Fair and Headcorn Apple Day offering apple-themed foods and drinks, recipes and folklore, traditional crafts, games and competitions; this fruit, so strongly associated with the Kentish landscape, certainly inspires a great deal of local affection!

APPLE WASSAILING AND YOWLING

Customs of winter wassailing are plentiful and ancient, their origins buried somewhere beyond the reach of recorded history. The ancient West Saxon greeting, 'Waes hael' (or 'good health'), is still commonly offered as a Twelfth Night toast (the correct response, by the way, is 'drink hael!' – or 'drink well') and the wishing of good health and prosperity to one's family and friends at the darkest time of the year is an enduring tradition, still very much observed in today's comparatively comfortable and cosseted society. While regional variations on the theme abound, in the south of England, it has long been customary to offer winter well-wishing to the livestock and crops upon which livelihoods depend and, in Kent, there is evidence that generations of grateful fruit farmers have extended these good wishes to their trees. In the 1585 mayoral accounts for Fordwich, there is a passage describing a local 'superstitious or old custom', performed on the eve of New Year and Epiphany:

> 'the boyes & servants at those tymes shall ffrom henceforth go into any mans orchardes or gardyns to beate the trees & sing vayne songes or otherwyse belevyng therby that those trees the yere following wyll or shall yeld the more plenty of frute...'[13]

Similar customs were flourishing throughout the nineteenth century when groups of Kentish 'yowlers' or 'howlers' carried wassail bowls through the county's abundant orchards in noisy and colourful processions. Here, they would place slices of toasted bread on and around the trees and pour cider over their roots while reciting or singing a blessing to ensure a good fruit crop for the following harvest. Edward Hasted encountered what he referred to as the 'odd custom' of 'youling' when he travelled through West Wickham and Keston in the late 1700s and describes (with no small degree of disdain!) a 'confused rabble' making a 'hideous noise' and speculates that the custom had

> 'arisen from the antient one of perambulation among the heathens, when they made their prayers to the gods, for the use and blessings of the fruits coming up, with thanksgivings for those of the preceding year.'[14]

In many of the county's towns and villages, this is a tradition that endures to this day and the custom of yowling is experiencing a significant revival. The New Ash Green Woodlands Group has been holding their annual wassail – an atmospheric evening of music and mulled cider – every January since 2007. It is a true village community event but also attracts visitors from farther afield, keen to join in the torchlit procession to the orchard's King Tree, which, adorned with its fairy-light crown, takes centre stage for the blessing ritual.

'YOWLING SONG' BY GAIL DUFF

The moon is up, the stars are bright,
The lantern's lit, the fire's alight,
And we are met in the cold night air,
This ancient rite to share.

Chorus (after each verse):
Apple Yowling
Voices howling
Success to the Old Apple Tree.

Our bowl it is made from the apple tree wood,
And bound with silver to make it good,
It's filled with cider spiced and hot,
The best that we have got.

We've toast for the Robins, so here they stay,
And salt to drive bad spirits away,
The cider we sprinkle all around,
To bring good luck to the ground.

Old Apple Tree, we Wassail thee,
May you bud and bloom and bear,
That when we come in another new year,
There'll be cider for all to share.

So make your shout and bang your drums,
Blow your horns and fire your guns,
Make it loud as ever you can,
To please the Apple Tree Man.

Wassail, Wassail, we sing Wassail,
Good health to all, may it never fail,
Take a drop from the bowl as you say, 'Drink Hael',
And join ion our Wassail.

So stand fast root and bear well top,
God send us a yowling crop,
Every twig, apples big, every bough, apples enow,
Hat fulls, cap fulls, bushel bushel bag fulls
And little heaps under the stairs.
Apple Yowling, Voices howling, Success to the Old Apple Tree.

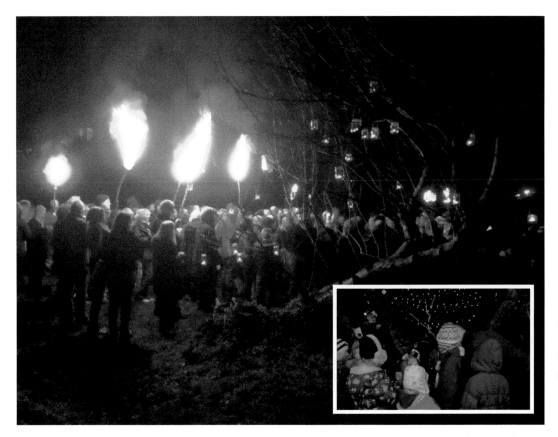

Above: The New Ash Green Woodlands Group at their annual January wassail. (Photograph Jerry Ash)

Inset: Wassailers feeding the robins in the orchard's fairy light-crowned King Tree. (Photograph New Ash Green Woodlands Group)

SOME KENT-NAMED VARIETIES OF APPLE

Beauty of Kent: this yellow-fleshed cooking apple, first recorded in 1790, has large fruits with a rich, sweet flavour and was a popular choice with the Victorians.

Flower of Kent: otherwise known as 'Isaac Newton's Apple' as it is believed that Newton was sitting beneath a tree of this green culinary variety when he was struck by the apple of inspiration. It is now a rarity.

Kentish Fillbasket: early descriptions of this variety differ greatly from the modern fruit, but its name is recorded from the 1760s onwards. It has vibrantly streaked, colourful skin and its richly flavoured, tangy flesh makes it an excellent cooking apple.

Maid of Kent: a bright red fruit with some pale green streaking to the skin and a crisp, white, fresh-flavoured flesh. Although records for this variety only date to the 1920s, it is believed to be an ancient cultivar, grown in both Kent and Sussex.

Christmas Pearmain: this is a Kent-bred, medium-sized dessert apple, introduced by apple grower George Bunyard in 1895. It has a rainbow skin of autumnal shades and a firm, rich, acidic flavour that matures in time for Christmas.[15]

CHERRIES

Prunus avium (the name translates as 'bird cherry') is also known by the names 'Wild Cherry', 'Sweet cherry', 'Gean' and 'Mazzard'. Confusingly, there is another species that we actually call the 'Bird Cherry' (*Prunus padus*), which has bitter-tasting fruits that are just too astringent for human consumption, but the birds aren't quite as fussy as we are.

Cyrre in Anglo-Saxon and *cerasum* in Latin, Kerasous, Turkey, is where it was believed cherries first found their way into Europe. In fact, the fruit is indigenous to most of the continent and it has been a common food source since prehistory. The popularity of cherries as a culinary delight is easily traced through documented history. We know that Kent cherries were prized by the Archbishop of Canterbury from at least the 1300s and there is evidence that they commanded good prices at market during the medieval period, but it seems that, in addition, they have long held value for their health-giving qualities. Culpeper writes about the differing properties of the diverse varieties of cherry commonly found in the British Isles but is most impressed by the usefulness of cherry tree sap, which he recommends for almost any ailment from a sore throat to kidney stones! Perhaps Culpeper was rather fulsome in his praise of this pretty little fruit but it appears that his hyperbole might have been founded in fact: researchers are only just beginning to record its potent health benefits and have found that the anthocyanins it contains (like other red and purple coloured fruits such as dark-skinned grapes, red apples and blueberries) have powerful anti-inflammatory properties; these compounds also work to reduce levels of uric acid in the blood stream, thereby lessening symptoms of gout, and it is possible that they might even relieve pain and stiffness associated with osteoarthritis. No wonder the people of Kent are such a hale and hearty folk!

Whether you like your cherries blush, black or red, fresh, cooked or juiced, there are hundreds of written recipes for cherry dishes and the cherry has long been enormously popular as a culinary ingredient. Some recipes, like one given in the fourteenth-century *Forme of Cury*, compiled by the 'master cooks of King Richard II', are surprising and might not appeal to the modern palate; this dish of almonds and cherries, cooked and served with 'good bread', and 'flourished' with anise, includes the ground cherry stones among its ingredients (they impart an intense almond-like flavour). Others are expensive: in his 1596 *The Good Huswife's Jewell*, Thomas Dawson offers us a 'close tarte of cherries' that features exotic cinnamon, ginger, rosewater and muscadine syrup in its list of ingredients. But it was a very simple bowl of fresh Kent cherries,

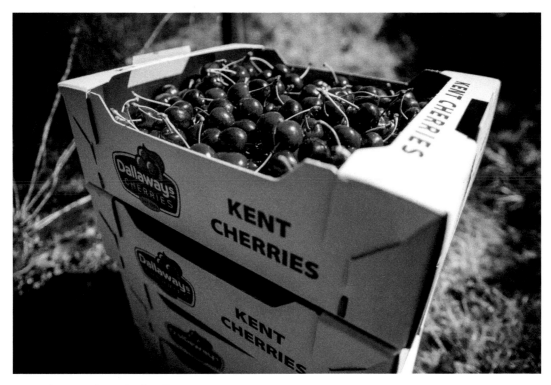

(Photograph Michael Dallaway)

ripe and flavoursome, that prompted Henry VIII to dub this county the 'Garden of England'.

When William Lambarde made his perambulation of the county in 1570, he was struck by its fecundity and wrote:

> 'In fertile and fruitfull woodes and trees, this country is most floryshing …as for ortchards of aples, and gardeins of cherries, and those of the most delicious and exquisite kindes that can be, no part of the realme (that I know) hath them, either in such quantitie and number, or with such arte and industrie, set and planted.'[16]

By this time, Richard Harris' mother orchards at Teynham, planted for Henry VIII some thirty years before, were well established and would have presented Lambarde with a stunning spectacle. Today, the descendants of those first, bountiful saplings are a staple feature of the Kent countryside, dappling the landscape with their April blossoms and dazzling with their July fruits. The cherry has become so much a part of the identity of the area around those original plantings that, in 1949, the emblem of a fruiting cherry tree and the motto 'known by their fruits' were incorporated into the Sittingbourne and Milton coat of arms; the same motto and the symbol of five red cherries were incorporated into the Swale crest in 1977. Harris' arboricultural adventure was a runaway success but the level of skill and care necessary for his achievement should not be underestimated as 'the cherry is a notoriously difficult crop to grow'[17]. Many of

A simple bowl of fresh Kent cherries was what prompted Henry VIII to dub the county the 'Garden of England'. (Photograph Pippa Palmar)

the cherry varieties grown commercially today were cultivated at Kent's East Malling Research Station, which was originally established in 1913 for the purposes of studying fruit production. The unique combination of Kent's soils and munificent microclimate might favour the cherry's prosperity, but care must be taken to plant compatible varieties which are likely to cross pollinate efficiently, and a sensible cherry grower will plant varieties that come into season in succession so as to avoid the waste of a cherry glut.

> 'Loveliest of trees, the cherry now
> Is hung with bloom along the bough,
> And stands about the woodland ride
> Wearing white for Eastertide.'[18]

One person who knows better than most the joys and hazards of cherry farming is Michael Dallaway. At his three Kent orchards in Sandhurst (and the one just across the county border in Northiam), Michael produces a unique, completely pure, fresh cherry juice, made with approximately 3 kg of cherries per litre ... and nothing else. His orchards are stocked with six different, good-flavoured varieties, ensuring a good spread of cropping across the season, and the farm's produce is sold at farmers' markets and farm shops across Kent, London and the south-east. When Michael's late father introduced the cherries to the family business in the 1980s, he was seen to be taking

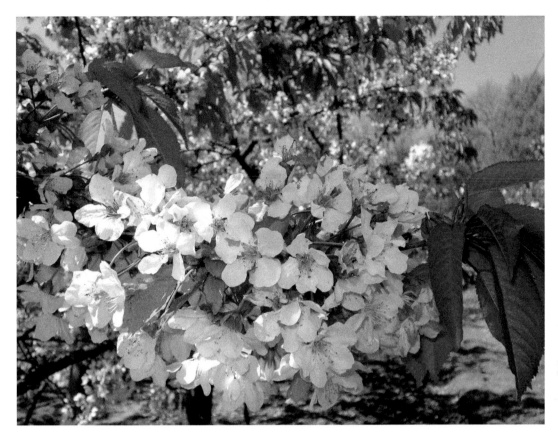

'Wearing white for Eastertide'. Billowing clouds of stunning cherry blossom are a familiar feature of a Kentish spring. (Photograph Michael Dallaway)

a risky gamble but, luckily, it was a gamble that paid off and twenty years later, when the time came to make a decision about renewing the farm's ageing apple orchard, Michael took the plunge and replaced those trees with cherries as well. As he says, 'we could always sell what we grew ten times again each year, so it seemed to make sense!'

As well as selling fresh fruit and the farm's unique cherry juice, the Dallaways have introduced two 'Kentish Tipples': a cherry brandy and a cherry vodka, both of which are flavoured with the smooth, rich warmth of their summer orchard fruits. Another diversification project was the launch of their innovative 'Rent-a-Cherry-Tree' sponsorship scheme whereby individuals can 'lease' a tree on an annual basis; members of the scheme receive regular updates about their tree's development throughout the year and are invited to enjoy the orchards across the seasons, from a walk among the spring blossoms to the gathering of their tree's crop in high summer. The scheme has been popular with people looking to enjoy local, seasonal fruit at its best and Michael says that many of their members bring along both older and younger family members to learn about and enjoy the cherries at picking time.

As Kent has been at the very heart of cherry production for centuries, it is little wonder that so many varieties have been named for places or people of the county;

Every litre of Michael Dallaway's pure cherry juice is produced from approximately 3 kg of fresh fruit. (Photograph Michael Dallaway)

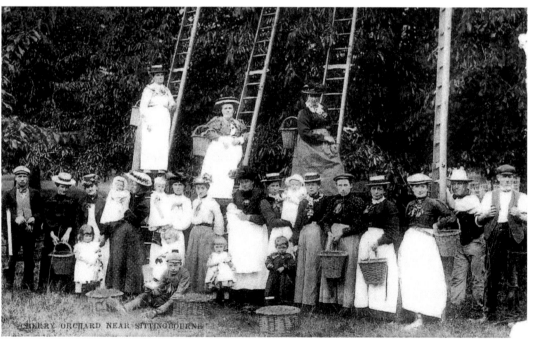

This group of Edwardian cherry pickers, harvesting near Sittingbourne, are using long cherry-picking ladders and traditional round baskets or 'kipseys' to collect the fruits. (Photograph Pippa Palmar)

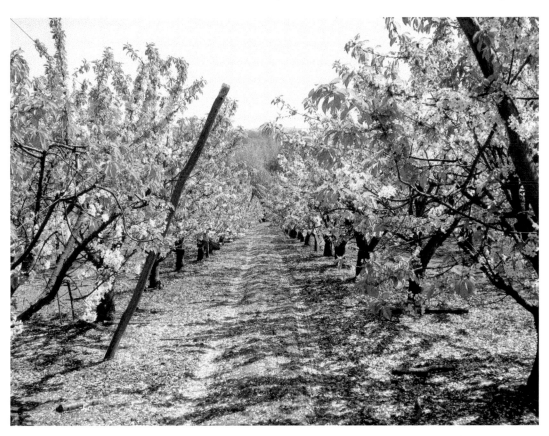

Modern cherries are grown on dwarfing stock, which makes routine maintenance and harvesting far more manageable. (Photograph Michael Dallaway)

the Bradbourne Black and Kentish Reds, the Wye Morello and Rodmersham Seedling all boast proudly of their provenance but perhaps the 'true' Kentish cherry could be considered to be Napoleon (or Naps), a blush, Bigarreau type cherry which, to our forebears, would have been a familiar feature of the landscape. Alongside the cherry trees would have been the equally familiar cherry pickers' ladders, hugely elongated versions of their domestic cousins, wide-splayed at the bottom for stability and built to reach into the canopies of trees that grew to well over 70 feet. Movement of these essential pieces of any cherry grower's equipment took careful planning and considerable manpower, and the risk to pickers of falling was the stuff of today's health and safety officers' nightmares! Modern cherry varieties are grown on dwarfing root stocks, such as Gisela 5 or Colt, and their height is further limited to ensure maximum fruit production and ease of harvesting, sometimes by pruning out the growing shoot or by tying branches down to encourage strong lateral growth (where the fruits will form). This sort of orchard management is labour intensive, and it can take five years to create a well-shaped and productive tree, but trees managed in this way are far more economical of space and nutrition and, ultimately, they produce more usable fruit.

TIPSY KENTISH CHERRY CAKE

The night before you want to bake the cake, wash and stone and chop into quarters 4 oz/100g of fresh Kent cherries and put them to soak overnight (or for at least a couple of hours) in 4–6 tablespoons of cherry brandy. This is a one-mix cake that works best if all your ingredients are at room temperature. Preheat the oven to 180°/gas mark 4. Now sift 6 oz/170 g of self-raising flour with a half teaspoon of baking powder and 1 teaspoon of ground cinnamon. Into the same bowl, add 6 oz/170 g caster sugar, 6 oz/170 g butter, 3 eggs, 1 oz/30 g ground almonds and ½ teaspoon almond or vanilla extract. Mix well until your batter is smooth and creamy. Remove the cherries from any remaining brandy (and reserve this for later) and toss fruit in a little flour to coat, then fold the cherries into the cake batter. Spoon your mixture into a loaf pan and sprinkle with Demerara sugar. Bake for about twenty to thirty minutes, or until the surface begins to turn golden, testing the cake by inserting a clean skewer into the centre; if it comes out clean, the cake is baked. You can cover the top with foil if it begins to brown too early. As soon as the cake is cooked, remove from oven and, whilst still hot, brush over with a couple of tablespoons of cherry brandy (you can use any remaining from soaking the fruits). The heat of the cake will evaporate the alcohol, but the delicious flavour will remain.

KENTISH CHERRY BATTER PUDDING

There are a number of variations on this recipe but it is, essentially, a very simple baked batter pudding. Before you begin, preheat the oven to 180°/gas mark 4. Butter a twelve-hole muffin pan, sprinkle with caster sugar and set aside. Mix together 8 oz/225 g of plain flour and 2 oz/60 g caster sugar. Into ½ pint/300 ml of milk, stir a teaspoon of vanilla or almond extract and beat in 2 large eggs. Carefully mix the liquid ingredients into the dry, incorporating slowly and beating well to avoid lumps. Pour batter into the prepared muffin pan and bake for about twenty minutes or until golden brown.

While the puddings bake, prepare the cherry sauce; use Kentish summer produce when at its freshest and do stone the fruit because cherry pits are extremely hard on the teeth! Put 1 lb/500 g of cherries into a saucepan with 4 oz/120 g of sugar and 5–6 tablespoons of water or cherry or apple juice. Heat gently until the fruit has softened then turn up the heat and stir while cooking until the sauce is thickened and glossy. You can add a few tablespoons of cherry brandy for a really decadent version. Once the little puddings are baked, turn them out and fill each round with a generous spoonful of the rich, ruby-coloured sauce. Serve warm with a little dollop of cream or yoghurt. If you are really pushed for time, you can simply throw the cherries and extra sugar into the batter mix and cook altogether in a large, shallow dish – this makes a lovely, fluffy, clafoutis-style dessert, studded with dark and delicious cherries.

STRAWBERRIES

Garden strawberry – *fragaria x ananassa*. Wild strawberry – *fragaria vesca*.

Wild, woodland strawberries have been recorded in England since the days of the Saxon kings, but their medicinal properties were well respected by the Romans and, undoubtedly, they were being enjoyed by the ancient Britons before the days of the Roman Empire. The pretty little plant featured in many of the illuminated manuscripts produced in medieval European monasteries: its dainty, pure white flowers were taken to symbolise the Virgin Mary and the startlingly red fruits represented the martyrdom of Christ, while the tripartite leaves echoed the Trinity.

From the 1300s, the European native musk or hautboys strawberry (*Fragaria moschata*) was introduced to the domestic fruit garden and, as a much-anticipated summer season delicacy, would have regularly graced the exclusive 'banquet', that sweet final course, of the meals served to honoured guests in the Tudor palaces. However, the larger varieties of strawberry with which we are familiar today would have been

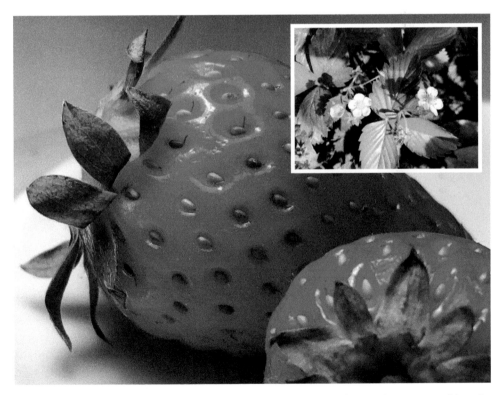

Above: Today's familiar varieties of strawberry were introduced from the New World in the 1600s.

Inset: Traditionally, the strawberry has strong religious associations: its trefoil leaf has been seen to represent the Holy Trinity, its white blossom the purity of the Virgin and the startling red of its fruit the blood of Christ. It was a popular motif in medieval manuscript illuminations.

unknown in England much before the late 1600s, when newly discovered Chilean and North American fruit cultivars were cross bred to produce the Virginian strawberry (*Fragaria virginiana*), which gradually spread across Europe. The English soon began development of larger, more flavoursome varieties and it wasn't long before these new examples were being referred to as 'English strawberries'. During the nineteenth century, enterprising Victorian fruit farmers and experimental breeders like Darwin's pal, Thomas Laxton, developed numerous new cultivars for the kitchen garden and table, including grandly named varieties such as 'Noble', 'Excelsior' and 'Royal Sovereign'.

A dish of strawberries and cream – reputed to have been a favourite treat at the table of Cardinal Wolsey – is now a staple feature at Wimbledon, where it made its debut in 1877. Very little has changed about this iconic delicacy in the intervening century and a half, but then what's not to like about fresh, Kent strawberries on a warm summer day? One Kent farm has been the sole supplier of this fruit (34,000 kg in 2019) for twenty-five years. Hugh Lowe Farms, at Mereworth, have been producing 'champion' strawberries for over a century. Literally: Bernard Champion planted his first crop in 1893 to supply his brothers' Covent Garden fruit stall and the business was an instant success. The farm passed to Bernard's grandson, Hugh Lowe, in 1955 and is now managed by Hugh's daughter, Marion Regan, and her husband, Jon.

As well as their famous strawberries, the Regans also produce blackberries and raspberries, so their fruit harvest is ongoing between May and November; every single berry is picked by hand and packed into recycled, recyclable punnets. Accountability and environmental sustainability are important to the Regans; as original members of LEAF (Linking Environment and Farming), they farm with a view to conserving the Kent landscape and producing good-quality food in harmony with nature. This means sharing their crop with wildlife such as bumblebees and honeybees (which act as vital pollinators for the berry plants) and careful land management through mixed farming.

Did you know that strawberries are packed with antioxidants? Culpeper recommended them for throat afflictions and inflammatory conditions; they can help protect the body against heart disease, can boost immunity, lower cholesterol and are also good for the skin.

COBNUTS

Corylus avellane. Varieties include 'Kentish Cob', 'Hall's Giant' and 'Ennis'.

In the darkest days of February, when the sky is washed in blue-black ink, the cobnut plats and hedgerow wildings are the place to find some sunshine – their heavy dusting of yellow pollen makes the catkins of the *Corylus* almost fluorescent at this time of year. As the trees are monoecious, you will also see the ruby tufts of the female flowers on the same branches, but not necessarily at the same time. The cobnut is a fairly happy tree, not much prone to pests or disease, and it thrives in the soils and microclimate of Kent, where it tends to crop more heavily than further north in the country. Little wonder, then, that the cobnut became so popular here. Hazels (of which cobnuts are

a variety) have grown wild in Britain since time immemorial and there is evidence that prehistoric man enjoyed a nutty crunch in his diet, but, while wild hazels are commonly found in ancient hedgerows marking old field boundaries and roadways, the domestic cultivation of the cobnut can only be reliably traced to the 1500s. At this time, we begin to see the first published cultivation advice and records of the planting of cobnuts in gardens and dedicated orchards, or plats; by the 1800s, the cobnut was big business, with around thirty known varieties in cultivation and Kent accounting for the majority of the country's 7,000 acres of cobnut plantation. Perhaps the best known of the nineteenth century introductions is Lambert's Filbert, also known as the Kentish Cob, which is now the most widely planted and well-known cob variety.

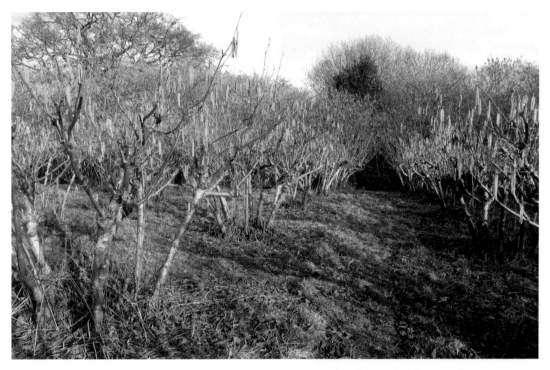

Above: Spring in a hundred-year-old cobnut plat. (Photograph Meg Game)

Right: Ripe Kentish cob. (Photograph Meg Game)

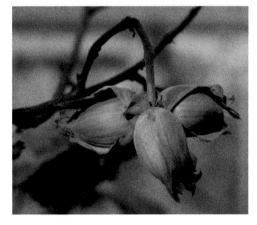

Farming trends, changing fashions and competition during the twentieth century saw a steep decline in cobnut production. However, today, there is renewed interest in this heritage crop and the county's surviving 200 or so acres of cobnut plat are being replanted, reinvigorated and mindfully managed. Much important research has been undertaken by Meg Game and the Kentish Cobnut Association, which she helped establish in 1990. Offering practical advice and a wealth of cob-cultivation knowledge, the association has encouraged and helped nurture new growth in the county's once-failing cobnut industry. Association Chair Gillian Jones manages a century old plat at Ightham Mote and, at Potash Farm in St Mary's Platt, Alexander Hunt has set about preserving another. With some support from the Kent Downs AONB Unit and the Medway Valley Countryside Partnership, Alexander has augmented an existing 500 tree plat (thought to date from the turn of the twentieth century) with 500 new plantings. The entire 6-acre site is managed in harmony with nature, making it a haven for wildlife and wildflowers and any by-products of routine maintenance, such as hazel sticks, are utilised in local gardens.

Above: Gillian Jones manages a cobnut plat on the Ightham Mote estate, Ivy Hatch. (Photograph Gillian Jones)

Inset: Kentish Cobnuts Association

Unlike most other nuts, which are dried before sale or use, the cobnut is sold fresh, often still in its distinctive, soft, green husk. Incidentally, this little 'jacket' gradually fades to a sandy brown colour after the nut is picked, so can be a good indicator of the age of a cobnut. Harvested from the end of the summer and through the early autumn, their season is short but they do store well. Luckily, cobnuts are once again being produced commercially in the county, and the fresh nuts are usually quite easy to find in farm shops and at farmers' markets at the end of the summer. As a food ingredient, the cobnut is extremely versatile, having a mild, clean taste when eaten raw and a rich, sweet flavour once dried or roasted. In most recipes, a cobnut can be used in place of a hazel; try adding a few fresh cobs to salads or crush with basil and garlic for a fresh-tasting pesto sauce. Gillian Jones suggests using cobnuts in biscotti: 'substitute roasted cobnuts for any other nuts that are suggested and add zest and juice of an orange for any other flavourings. They are delicious!'. Cobnuts can even be transformed into a dairy-free milk alternative: simply roast the cobs in a medium oven to release more of their nutty flavour, soak in water overnight and blitz in a food processor. Traditionally, the hazel or filbert is recommended as a cough remedy (Culpeper advises mixing with honey or mead) and modern medical research shows that the simple cobnut boasts multiple health benefits, being rich in vitamin E and calcium and also containing significant levels of vitamins B1 and B6.

The name 'cob' nut is a bit of a mystery, but it might derive from a children's game, played like 'conkers', with nuts threaded onto lengths of string, in which the victorious nut was deemed 'The Cob' – perhaps D.H. Lawrence is referencing the Kentish Cob when Walter Morel recounts tales of his champion 'cobbler' in *Sons and Lovers*. Did you know that another name for Hallowe'en is Nut Crack Night? According to tradition, unmarried men and women placed hazel or cobnuts into the fire to determine the courses of their amorous relationships; a slow, quiet burn would indicate a smooth courtship, whereas jumping or popping nuts warned of a rather rocky romance ahead!

KENTISH COBNUT CAKE

This simple sponge is infused with the rich flavour of roasted cobnuts and spiced with nutmeg and cinnamon. Weigh three eggs in their shells and measure out the same weight of self-raising flour, soft butter and light brown sugar. Gently toast 3 oz (or 100 g) of shelled cobnuts – either on a baking tray in the oven or in a clean, non-stick frying pan (no need for any oil). Once toasted and cooled, crush these in a blender or pestle and mortar. Stir all the ingredients together and add a teaspoon of cinnamon and a quarter teaspoon of nutmeg. Mix well and spoon batter into a loaf pan or 8 inch/20 cm baking tin, sprinkle with Demerara sugar and bake at 180°C/gas mark 4 for twenty minutes or until firm and golden brown. A delicious treat with a mid-afternoon cup of tea or coffee.

Fruits of the Sea

As a coastal county, Kent has a long and proud fishing heritage and, although the numbers of commercial fishermen might have fallen in recent years, from Dungeness, Folkestone, Ramsgate, Whitstable and Queenborough, Kent fishermen are still braving the perilous North Sea waters to bring home the daily catch. The Kent and Essex inshore fishing fleet – which, in 2020, was recognised as one of Britain's 'critical industries' – comprises around 200 licensed fishing vessels; eighty of these are full-time and the majority are small, independent boats of less than 10 metres. Its nutritional value makes fish a fundamental component of a balanced, healthy diet and there is a huge diversity of fish and seafood to be found off the Kent coast, including gurnard and skate, turbot and brill, as well as scallops, crab and lobster. However, local fishermen and fishmongers have noticed marked changes in both the numbers

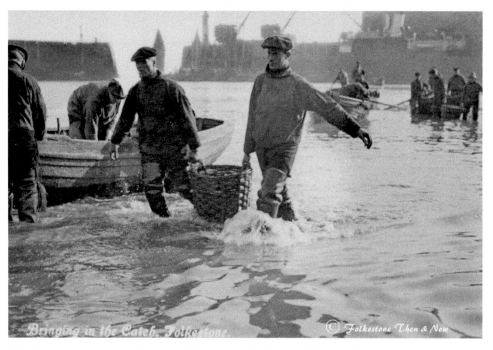

Bringing in the catch at Folkestone. (Photograph Folkestone Then and Now)

and the species of fish present around the Kent coast over the last twenty to thirty years. This is due, in part, to the effects of rising sea temperatures on the migratory and breeding habits of some species; mackerel, for instance – once so abundant in the area – is far more likely to be found, today, in the cooler waters around Iceland than off the Kent coast[19]. Broad changes in fishing practice are also effecting substantial changes; for example, shoals of cod – previously a staple in south-eastern waters – have been decreasing significantly, in line with the increasing deployment of huge-scale industrial trawler fishing boats in the same area. In addition to this, British people are simply not buying fresh fish in the sorts of quantities they used to and up to 80 per cent of the Kent daily haul is sent outside the county, with much heading across the Channel into Europe.

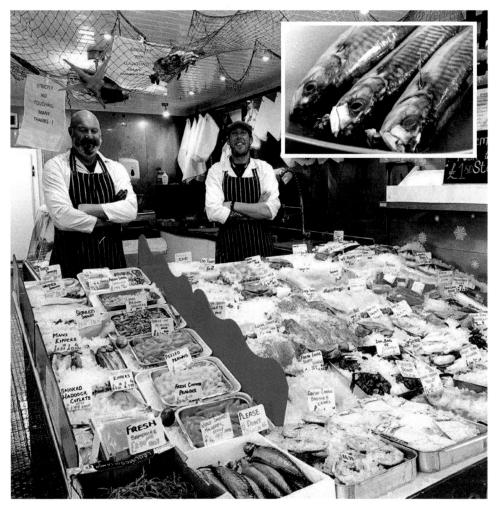

Above: Darren Jenkins (right), of Jenkins & Son in Deal, is a fourth generation Kent fishmonger, proudly supporting the county's fishing industry. (Photograph Darren Jenkins)

Inset: Locally caught mackerel. (Photograph Darren Jenkins)

As the fourth generation in a family of fishmongers, Darren Jenkins, of Jenkins & Son in Deal, knows better than most just how susceptible to changes in foodie fashion the fishing industry is; in the last twenty years, he has seen the preferences of celebrity chefs and stylish London restaurants pushing up prices of 'choice' catches such as lobster, Dover sole, bass and salmon, while the popular fish choices of the 1970s and 1980s, such as herring, skate or cod cheeks, now regarded as 'cheap', have been displaced. He has also seen changes in his customer base, which has been expanded by the influx of a new generation of 'Down-From-London-ers' demanding fresh fish for experimental forays into 'designer' cooking. Darren is passionate about the protection of British waters and the responsible conservation of their stocks and so maintains a dependable, fresh supply chain with full traceability; 'we usually know not only who caught it, but where and how,' he says. This practice makes good business sense, but it is also providing crucial support for the independent, inshore, day-boat operators that have been at the core of the local fishing community for centuries.

DOVER SOLE

Solea solea is a flatfish to be found basking in the sandy bed of the temperate Mediterranean Sea and eastern Atlantic Ocean. However, in more northerly regions, it tends to gravitate towards the warmer, southern climes of the North Sea in the colder winter months. Its dull colouring affords the sole excellent camouflage against the mud and sands of the seabed surface, where it lays in wait for unsuspecting prey. Despite its unremarkable appearance, the Dover sole is one of Kent's culinary celebrities and takes its moniker from the Channel port at which vast numbers of the fish were landed in the nineteenth century.

Dover sole earned its geographic appellation during the 1800s, when thousands of this unassuming fish were regularly hauled into Dover harbour. (Photograph Darren Jenkins)

The firm, sweet flesh of the Dover sole makes it a favourite with seafood lovers and cooks, and many cooking recommendations advise very simply quick-frying or grilling fillets for best results. In the medieval kitchen, fast-day meals would have been prepared from good fish if it was available and in Kent – particularly along the coast – fresh fish would have been in plentiful supply, adding valuable nutrition and variety to the local diet. Several medieval recipes are known for fish mortrews (a sort of pâté made by pounding cooked fish in a mortar) and, in the fourteenth-century cookbook *The Forme of Cury*, an extravagant recipe is given for sole in a spiced, onion sauce:

SOOLES IN CYNEE [an onion sauce]
Take Soles and hylde [skin] hem, seeþ hem in water, smyte hem on pecys and take away the fynnes. take oynouns iboiled & grynde the fynnes þerwith and brede [roast]. drawe it up with the self broth. do þerto powdour fort (a spice mix containing, among other things, pepper and ginger), safroun & hony clarified with salt, seeþ it alle yfere. broile the sooles & messe it in dysshes & lay the sewe [stock] above. & serue forth.[20]

WHITSTABLE OYSTERS

The wild, native oyster (*Ostrea edulis*) is a modest little mollusc: its flat, rounded shell is rough-textured, pale coloured and sometimes streaked with the greens, browns and greys of a Kent winter seascape. Once prolific from Norway to Morocco, it thrives on the rocky substrate of shallow waters such as the chilly, brackish, coastal stretches of the Thames Estuary, but in the last hundred years UK numbers have declined by 95 per cent and it is becoming an increasingly rare treasure in these parts. Across Europe, the native oyster reef is one of the most severely threatened natural habitats, which is why responsibly managed hatcheries such as those around the British Isles are so important to its conservation.

(Photograph Simply Oysters)

Downed in one or savoured for their flavour, eaten cooked or raw, throughout history, the oyster has been highly valued as a food source. The North Atlantic specimen is a slow-growing variety, larger than its warmer-water Mediterranean cousin and with a sweeter, firmer, more succulent meat. The Romans were quick to spot the commercial potential of this bountiful Kentish harvest; considered to rival the excellent oysters found in the 'little sea' of Lake Lucrine, there is evidence that Kent oysters were regularly exported to the continent, where they were highly valued and believed to impart great fighting prowess. Incidentally, if you have ever wondered about the oyster's reputation as an aphrodisiac, it stems from the Romans' association of the little shellfish with the goddess Venus. The monks at Faversham's medieval abbey exercised strict control over their valuable local oyster harvest and archaeological excavations at the abbey site have uncovered discarded oyster shells containing traces of medieval pigments, revealing how these versatile little receptacles, once emptied, were recycled for use as mixing dishes by the abbey's illuminators.

The Pollard Ground off Whitstable and the Ham Ground off the Isle of Sheppey were providing fare for the refectory tables at Canterbury Cathedral long before the Norman Conquest. The Court of Fishing and Dredging oversaw the trade for centuries but in 1793, the Company of Free Fishers and Dredgers of Whitstable was officially incorporated by Act of Parliament to regulate this lucrative industry and to protect the rights of the town's free fishermen. Run as a cooperative, for the mutual benefit of its members, its success fuelled the expansion and prosperity of the town and, within a century of its foundation, the company was running a dredging fleet of around a hundred 'smacks', selling around 80 million oysters a year. Their success reached a peak in the mid-nineteenth century, catering largely to the working-class masses of Victorian London for, as Sam Weller remarked in Dickens' *Pickwick Papers*, 'poverty and oysters always seem to go together… the poorer a place is, the greater call there seems to be for oysters'.[21]

The Whitstable oyster fleet unloading the day's catch. (Photograph S. Axford)

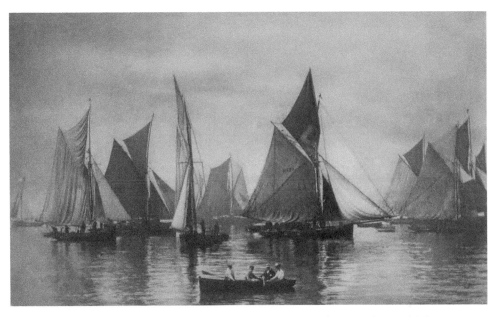

Oysters were dredged by fleets of 'smacks' during the 1800s. (Photograph S. Axford)

Years of overfishing, pollution and the decimation of stocks by disease, to say nothing of cheap imports and changes in culinary fashion, had brought the industry to its knees by the 1960s. However, under the enterprising auspices of brothers James and Richard Green, the company was reinvigorated in the 1980s with the opening of the celebrated Whitstable Oyster Fishery Company restaurant on the Whitstable seafront. As the company continued to flourish along with the fortunes of the town, so it expanded, and returned to oyster production in 2001. Today, they are, once again, supplying oysters to the domestic market and exporting to Europe, bringing the Kent oyster's ancient story full circle.

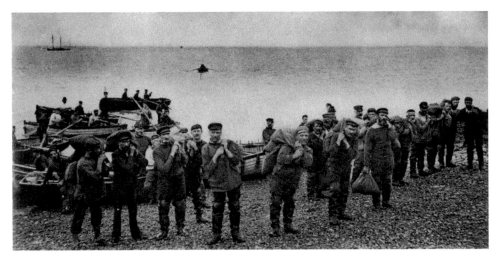

Landing the oyster catch, Seasalter and Ham, *c.* 1900. (Photograph S. Axford)

WHITSTABLE DREDGERMAN'S BREAKFAST

This is the way to start a day of hard work, battling the elements and the cold North Sea: a hearty sandwich, made with bacon and cooked oysters, served between thick hunks of crusty bread. Believed to have originated in the days when oysters were commonplace and cheap, it's easy to imagine how this might have become a popular dish, widely enjoyed in the town's fishing community. It is, perhaps, a variation on the more elegant Angels on Horseback hors d'oeuvre (which consists of plump oysters, wrapped in bacon) and, although the roots of both these dishes are far from certain, many sources agree that Whitstable is their most likely place of origin, due to the prestigious reputation of the oysters to be found along the town's shore.

FOLKESTONE FISH PIES

The annual Folkestone Trawler Race and Fun Day is a two-day celebration of the harbour town, its heritage and its close-knit community, built upon generations of fishing families. One of the highlights of the weekend is the famous Mison's Fish Pie Competition, sponsored by the aptly named Mariner pub, which is situated along the historic, cobbled seafront on The Stade. This harbour-facing street has borne witness

Above: The fish market on Folkestone's seafront, *c.* 1900. (Photograph Folkestone Then and Now)

Inset: (Photograph Folkestone Then and Now)

Cath Mison's Fish Pie competition is a mainstay of the Folkestone Fun Day. (Photograph Cath Mison)

to the ebb and flow of the history of Folkestone's fleet: here is where generations of fishermen have sat to repair their nets or hung them out to dry and sold their daily catches from harbour-side stalls. The fish market – safely ensconced in the shelter of the harbour – was once the centre of a thriving local industry, bustling with frenetic activity after every day's landing. The scale of this trade might have changed over the past century, but Folkestone is still very much a busy fishing port.

The Fish Pie Competition is far more than just a chance for locals to show off their culinary prowess; it is an opportunity to showcase the tremendous quality of locally sourced fish, as all pies must be made from Folkestone produce. As organiser Cath Mison explains, 'the whole idea is to encourage people to buy fresh fish and to support our fishermen – our fleet here in Folkestone is getting smaller and it would be so sad to lose it'. Cath's own 'champion' fish pie recipe incorporates leeks, cheese and capers, but its basis is a rich and colourful mix of good quality, fresh fish, including cod, haddock and salmon – as Cath describes it, it is 'Folkestone in a bowl'!

Baked Goods

KENTISH HUFFKINS

Ligurians are proud of their focaccia and New Yorkers treasure their bagels, but in Kent we seem to have fallen a little out of love with our own local speciality bread. A traditional staple product even up to the time of the Second World War, the Kentish huffkin would once have been a familiar sight at every table or in every field worker's lunch hamper. Instantly recognisable from the distinctive indentation, made by the baker's thumb imprint, in the centre of its top (a convenient repository for a spoonful of cherry jam or Kentish honey!) this soft-crusted, flat, round bread roll is traditionally served with a filling of pitted cherries for a sweet treat or may be filled with crispy bacon for a hearty breakfast.

Baking the perfect huffkin requires care, patience and time; little wonder, perhaps, that the larger commercial bakeries tend to omit the huffkin from their menu. However, it can be purchased from a few local suppliers and the Speciality Breads bakery in Margate have been producing traditional huffkins for more than a decade. Originally made from stoneground flour from Sarre and now using wheat milled at Eckley Farms in Staplehurst, Speciality Bread's huffkin has enjoyed steady popularity

The cloud-soft huffkin, with its distinctive dimple, is Kent's traditional bread roll. (Photograph © Speciality Breads)

since it was introduced to their range in 2006 and was awarded a Highly Commended Taste of Kent award in 2020. But if you cannot find them to buy, it is not too difficult to make a batch of huffkins at home and the rich, beery fragrance of rising dough is infused with reminders of generations of forebears who produced household loaves on a daily basis as a matter of course. As with all good breads, the huffkin's ingredient list is short and simple: flour, yeast and water, plus a small amount of fat and a pinch each of sugar and salt. The key is allowing time for two risings of the dough; this allows for the formation of a soft, open crumb and gives the huffkin its cloudily delicate texture and tender crust. After baking, the secret is to wrap the still-warm huffkins in damp tea towels to prevent their outer crusts from toughening as they cool. Eat your huffkins warm, with butter and jam, or try with fresh soft fruits and cream for a Kentish cream tea; swap the strawberries for baked apples and roast cobnut butter in the autumn. As the bread mix is not a sweetened dough, the huffkin serves just as well as a plain roll to eat soft or toasted with soup, or filled with your favourite sandwich filling; try with Kentish blue cheese or, alternatively, it makes a great base for Kentish rarebit.

KENTISH RAREBIT

This is a simple, easily prepared meal that was particularly popular with fruit and hop pickers across Kent during the nineteenth and early twentieth centuries. Essentially, this is cheese on toast with a twist and that twist is the addition of a layer of apple slices underneath the cheesy topping. Finely slice an eating apple and gently cook the pieces in some butter until they soften and begin to brown. Layer some of the apples onto slices of bread or a split huffkin and cover with cheese before grilling until bubbling and golden. It's easy to see how, in the middle of the autumn harvest, this simple dish would have made a warming and tasty meal for farm workers on the go; a good example of making the best use of plentiful produce, it would have been a particularly popular choice in the long, golden days of September but, as these began to dwindle into the chill of winter, it was also a good way to use stored apples, which might not taste their best after a few months in the apple loft.

BIDDENDEN DOLE

In the village of Biddenden, there is an old and generous tradition of providing gifts for the needy at Easter. The distribution of the Biddenden Dole, originally administered at the church after the Easter Sunday service, is a ritual that has endured over 500 years. The generosity of the dole gift was legendary: eighteenth-century writer Edward Hasted tells us that the annual dole comprised of 270 three and a half pound loaves, plus 600 Biddenden cakes, and at Easter 1808, 1,000 dole cakes were thrown out from the church tower. In addition to this, each parishioner could also expect to receive a pound and a half of cheese and a measure of that other life staple of the rural poor – beer. Little wonder, then, that, at the height of its popularity, this yearly ritual

drew interest from far and wide. An account from 1826 describes the village as being 'completely thronged with visitors' at doling time every year but there is also evidence, recorded in the 1600s, of disorderly behaviour disrupting the Easter service as crowds gathered in anticipation of the free feast to come. Eventually, the dole distribution and all its associated rowdy shenanigans were removed to the parish workhouse – and more lately the village hall – in desperate attempts to preserve the sanctity of All Saints.

The true origins of the dole custom are much debated. It is commonly believed that the 22 acres of land from which the charity's income was derived were bequeathed to the village by legendary local sisters Eliza and Mary Chulkhurst, conjoined twins who are believed to have lived the entirety of their thirty-four years in the village, having been born in either 1100 or 1500. The confusion over their date of birth is just one of the many details over which locals and historians disagree but the general popularity of the Chulkhurst story is evident in the village, where an image of the sisters, resplendent in blue and gold, watches over the green from the village sign. In 1907, the 'bread and cheese lands' (as they became known) were sold for housing and the resulting income used to build a parish clubhouse and to expand the scope and reach of the dole gift. By the time of the Second World War, this also incorporated money, fuel, nursing and medical treatments and, in recent years, the charity's trustees have delivered food parcels around the parish, including bread and cheese, butter and tea (long gone is the labourer's ale!), or granted gifts of cash.

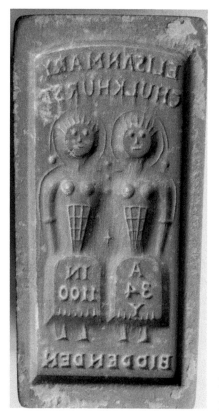

One of the few surviving Biddenden Dole cake moulds, showing the legendary Chulkhurst sisters. This one bears the date 1100. (Photograph Tom Lupton)

The famous Biddenden cakes, 'which have the figures of two women impressed on them'[22], were made from moulds, several of which have been preserved in and around the village. All the surviving moulds feature the Chulkhursts, clearly identified by name and date, further reaffirming the tradition of the link between the charity and the sisters. However, Hasted – who had no time for what he called the 'vulgar tradition' of the Chulkhursts – claimed that the two women depicted on the cakes merely represented 'two poor widows as the general objects of a charitable benefaction'[23] and there are engravings of older versions that feature no written details at all. The cakes themselves were very hard-baked (some say inedible!), biscuit-like confections but were much sought after and regarded as a very special Easter treat by those lucky enough to receive one.

GYPSY TART

For many people in Kent, this tooth-achingly sweet dessert is a delicious memory associated with childhood and school dinners and, certainly, the simplicity of the recipe and its minimalist ingredients list make this a firm favourite for caterers and household cooks alike. But there is a tale behind the tart and one which gives an interesting insight into Kent rural life at the turn of the last century. According to popular stories, when one elderly Kent woman saw some gypsy children playing in the fields near her

Above: Throughout the year, work in the Kent fields and hop gardens provided significant employment to the Romany community like this group encamped near Maidstone, *c*. 1890. (Photograph Stocks Farm)

Inset: Gypsy Tart, a simple but rich dessert created out of kindness.

Sheppey home, she was shocked by their emaciated appearance. Worried for their health, she felt moved to cook them something nourishing from the meagre supplies in her kitchen cupboard and made a quick and simple pastry case which she filled with a whipped mixture of sugar and evaporated milk. The soft, caramel warmth of this delicious confectionary proved irresistible to the hungry children, who ate it with gusto and no small measure of gratitude.

It's a sweet story and it might well be true. Until the 1950s, Traveller families accounted for a major part of the Kent agricultural workforce all the way around the farming year. In late spring and summer, they would assist with hop training, then fruit and vegetable picking before the August or September hop harvest; in the autumn, they worked to gather the fruit harvest and lift potatoes and, in the winter, some were paid by farmers to control the rabbit population. Temporary Travellers' camps would spring up on the common ground around the county, usually moving every few days as the nature and quantity of work shifted with the season. In winter months, the community would gravitate towards the edges of larger towns or migrate northwards towards the fringes of the capital, supplementing the family income with casual labour, basket weaving, knife sharpening or by selling every day domestic items such as clothes pegs or hand-carved ornaments.

TO MAKE A GYPSY TART

Prepare and blind bake a pastry pie case and remove from the oven. Set oven temperature to 150°C/gas mark 2. Whisk together equal parts evaporated milk and dark muscovado sugar until light and mousse-like; this might take twenty minutes but is worth the time and effort (which isn't much if you have an electric mixer). Pour the filling into the pastry case and bake for around ten minutes, or until the filling is set. Be careful not to over-bake as the sugar will liquefy and ruin the tart. Remove from the oven and serve with some sharp, crisp apple slices for a thoroughly Kentish teatime treat.

CANTERBURY TART

This apple-based dessert dish combines sweet and sharp apples and is an excellent way to use up any sort of apple glut. It is quite possible that the Canterbury Tart is derived from a medieval recipe recorded in the fourteenth-century cookbook *The Forme of Cury*, which offers a recipe 'for to make tartys in applis' from 'good apples and good spices and figs and raisins and pears', cooked and coloured with saffron and baked in a pastry case. There is no mention, here, of sugar, which was even more rare a luxury than figs or raisins in the England of Geoffrey Chaucer. The instructions advise that the apples be 'abraded' – or grated – before cooking and the Canterbury Tart is made in a similar way, with grated or finely chopped sharp apples being mixed with eggs, sugar and lemon juice for the pie filling. Sweet dessert apples, sliced thinly, are laid on top of the filling and sprinkled with demerara sugar before baking. It is not difficult

to imagine that this tart might have earned itself a place among the favourite dishes of the monks at Canterbury, who would have had a plentiful supply of apples from their own orchards.

FOLKESTONE PUDDING PIE

Also known as Kentish Lenten Pie, this delightful concoction combines a short pastry crust with a rice pudding filling and really seems rather too luxurious for any Lenten repast. In his book *The Dover Road*, Charles G. Harper writes about the loss of the traditional pudding pie, which he describes as an 'old-time Kentish delicacy' that 'was once to be had for the asking at any inn during Easter week'[24]. Harper's description gives us a saucer-sized, flat custard tart, lightly scattered with currants. Variations on the recipe abound because, like the Canterbury Tart and Gypsy Tart, the origins of this dish have long dissolved into local legend and no one recipe can claim definitive authority. However, it is generally agreed that the basis is a good pastry shell filled with a rice-thickened, sweet custard; some versions advise infusing the custard with bay or citrus peel and some call for the addition of a handful of currants – possibly soaked in sherry or sweet Marsala.

Field Fare

THE ROMNEY SHEEP

The Romney Marsh – described by Betjeman as a landscape always three quarters sky – is a wide, flat expanse of the east Kent coast, stretching from Hythe in the north to New Romney in the south and roughly bounded by the Military Canal to Appledore in the west. In his *Ingoldsby Legends*, Kent cleric Richard Harris Barham described this area as the 'fifth quarter of the globe', steeped in myth and magic and a likely haunt of witches. However, the less fanciful William Cobbett, when passing through in the 1820s, noticed a rather more earthly feature to the vista, describing it as follows:

> 'In quitting this Appledore I crossed a canal and entered on Romney Marsh. This was grass-land on both sides of me to a great distance. The flocks and herds immense. The sheep are of a breed that takes its name from the marsh. They are called Romney Marsh sheep. Very pretty and large. The wethers, when fat, weigh about twelve stone; or, one hundred pounds. The faces of these sheep are white; and, indeed, the whole sheep is as white as a piece of writing-paper. The wool does not look dirty and oily like that of other sheep … with sheep such as I have spoken of … this Marsh abounds in every part of it; and the sight is most beautiful.'[25]

Of course, grazing sheep were a common sight across the county for centuries – they even gave the descriptive Old English name 'sceapig', meaning 'sheep island', to the north Kent Isle of Sheppey – and Cobbett's description was not exaggerated; at the time of his riding, he might have witnessed a quarter of a million sheep spread across the marshes and it is not difficult to imagine the dazzling white of their distinctive coats glittering against the grey-green of the grass like so many pearls. In the 1800s, the Romney Marsh sheep, as it was then known, became one of the most prolific and successful breeds in the country. As the breed's popularity increased, its name was altered and it became known as the 'Kent' sheep. But national domination did not satisfy this opportunistic ovine and, when fifty specimens were shipped from Kent to New Zealand in the 1850s, the Romney (as it was, and is now, known) took the world by storm. This tiny starter flock would become the progenitor of the New Zealand lamb industry and further exports saw similar sheep-farming endeavours established

Romney sheep are a hardy variety, well adapted to the harsh climate of the east Kent marshes and now farmed widely across the globe. (Photograph Julie Murray.)

in Australia, Canada and South America by the start of the 1900s – little wonder the Romney is often referred to as 'the best-known sheep in the world'.

Prized for the unsurpassable quality of its generous, heavy, long-wool fleece, the Romney was originally developed to satisfy the voracious medieval appetite for valuable English wool cloth, but this hardy and versatile breed is a true dual-purpose variety, valued as much for its meat as its mantle. The Romney offers as attractive an economic opportunity today as it did for the Kent sheep farmer in the heyday of the English wool trade. A hardy sheep, it requires little attention on the exposed marshland terrain where it was developed and adapts well to its environment; its talent for foraging means that flocks can be stocked densely, making the best use of the land – from the heights of the North Downs to the low-lying east coast marshes – and the relatively large size of the animals provides a good yield of both fleece and meat. In the changing economic climate of the twentieth century, declining sheep prices gradually eroded the county's tradition of sheep farming and Cobbett might have been shocked by the transformation in the landscape. The Corn Production Act of 1917 and the 'plough up' scheme, introduced during the Second World War, saw acres of Kentish pasture made over to arable and, consequently, a dramatic fall in the numbers of sheep on the land.

However, in the twenty-first century, the Romney remains a force to be reckoned with. at Aragon Farm in Sissinghurst, Hugh and Pauline Skinner have spent forty years building up their breeding flock, which is regarded as world-leading in performance indices across the board. The quality of Aragon stock is helping to ensure the health and popularity of the breed for future generations. At Snoad Farm, in Otterden, David, Julie and Matthew Murray breed and show champion Romneys, selling their superior meat through independent retailers and an innovative home-delivery box scheme. The Romney's hardiness makes it a great choice for the windy tops of the Downs; as Julie explains, they are 'a great native breed. Not the most prolific, but long-lived hardy, surviving on rough pasture and a great ewe for crossing with other Terminal Sires to give a perfect butcher's lamb'. Its versatility means the breed is still farmed right across the county and its meat – from new spring lamb to well-matured mutton – remains a universally popular choice.

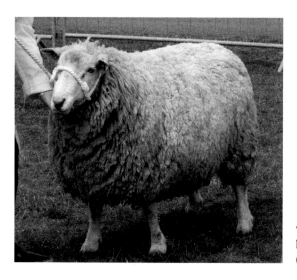

'Mr Barr' – Champion Romney
bred by the Murrays of Snoad Farm.
(Photograph Julie Murray)

Julie recommends a slow-roasted shoulder of lamb (which has more fat and flavour than other joints), cooked on a low heat for four hours, with stalks of rosemary, a few garlic cloves and a slug white wine – 'falls apart: lovely,' she says. There is some speculation, but little evidence, that the dish known as 'lambs' tail pie' originated on the Romney Marsh. A concoction of discarded docked lambs' tails and a medley of root vegetables in a pastry crust, this seasonal dish associated with the spring lambing season has fallen out of favour but variations on this theme can still be found on some local menus.

RAPESEED OIL

A field of oilseed rape in full flower is not easily missed; there are people who complain about these shocking yellow flashes on the landscape and there are people who love their buttery, sunshine glow. I know which camp I fall into. At Eckley Farms in Staplehurst, around a hundred acres of oilseed are grown each year as a break crop – planted to allow the land to rest between seasons of wheat production. Originally, all this seed was sold as a commodity until the Eckleys decided to experiment with pressing their own rapeseed oil from 1 ton of seed ... and they haven't looked back. Today, they cold-press their whole acreage and sell their Pure Kent oils and dressings directly to the public. Made from a single variety of seed, their award-winning oil contains no solvents and no heat is used in the extraction, so the product retains its full nutrient content as well as its bright, gold colour and distinctly sweet, nutty flavour. It is extremely popular and no wonder; as Claire Eckley explains, 'cold pressed rapeseed oil is very versatile – there's no need to have bottles of different oils in your cupboard, as rapeseed oil can be used at low and very high temperatures, like roasting and stir frying. It is lower in saturated fat than most culinary oils, and high in omega oils'. Claire suggests using rapeseed oil in cakes, to reduce their saturated fat content and improve keeping qualities or using it to make Yorkshire puddings as its very high burn point means the puddings won't stick to their tins. In recent years, many farmers

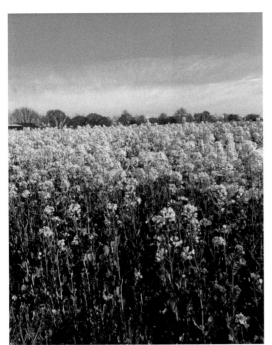

Pure Kent Oils are cold pressed from single variety rapeseed. (Photograph Claire Eckley)

have begun to abandon the rapeseed plant as it has come under threat, particularly from the flea beetle, but the Eckleys are working on developing environmentally sustainable controls, such as companion planting, to combat the problem. Kentish Oils and Condiments, based near Canterbury, are another small, independent concern producing award-winning, cold-pressed rapeseed oil. Since 2008, they have been expanding their range of blended oils and oil-based condiments, which now includes a number of dressings and a mayonnaise range.

Wild Wonders and Unexpected Delights

WILD FOODS

A walk in the Kent countryside can take you from the chalk hill downs to the estuary marshes, from the White Cliffs to the Wealden woods, and its widely varied topography supports a huge diversity of natural habitat, providing an abundance of fresh resources for the county's growing legion of wild food foragers. This practice has seen a dramatic growth since the 1990s and the Association of Food Foragers (established in 2015) provides support, advice and educational resources about good foraging practice and responsible land use. But foraging is nothing new; there is evidence throughout history of people making use of nature's fresh bounty – particularly in times of dearth – and as recently as the Second World War, we have collections of 'hedgerow' recipes, from bramble Christmas mincemeat to acorn and dandelion coffees. Most people will have encountered wild mushrooms and the native Cep, Parasol and Chanterelle mushrooms can be found in abundance across the region, but there is a profusion of produce available if you just know where to look. One passionate wild food forager who knows exactly where to look is Michael White, founder of Rural Courses. He is extremely knowledgeable and his foraging supplements his self-sufficient lifestyle in the heart of the county. When pressed to name his favourite foraged fare, Michael plumps for spring reedmace shoots, picked young, lightly steamed and tossed in butter. And Michael is not alone in his appreciation of the more unusual delights of the 'wild larder'; in recent years, wild hop shoots – gathered in the early spring – have become the most expensive vegetable in the world, commanding prices of up to €1,000 per kilo. But regardless of current foodie fads and fashion, foraging is a sustainable way of life in the Kent countryside.

Throughout the year, the Kent hedgerows, woodlands and field margins provide an ever-changing seasonal menu of fresh produce. Spring shoots of nettles, chickweed, hairy bittercress and goose grass can all be used fresh in salads, while early wild garlic – so easily identified by its pungent scent – has a sweet, mild flavour that lends itself well to dishes both raw and cooked. The shy flowers of wild violets can be crystallised or made into a syrup and used to add colour and flavour to confectionary and desserts. As the summer gathers strength, so the wild larder begins to bloom: now is the time to pick the flowers of almond-flavoured May and honey-scented red clover to add to salads, syrups or desserts or to collect elderflowers for making that delicate, fragrant

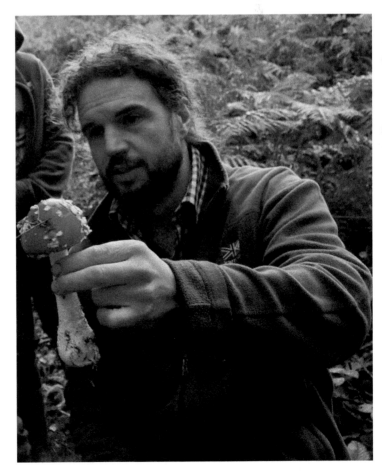

Expert forager Michael White runs rural courses from his Kent home. (Photograph Michael White)

cordial, so redolent of an English summer garden. The petals of the wild dog-rose, used fresh, as syrup or dried for use in Middle Eastern cuisine, are infinitely versatile and are perfect for flavouring home-made Turkish delight. The potent flowers of honeysuckle – at their best if picked in the evening – make a wonderful tea, cordial or syrup for cocktails, while lime flowers – so headily perfumed – make a mildly sedative evening tisane. Beneath the summer woodland canopy or in the shade of the hedgerow, you might be lucky enough to discover some wild strawberries; they are smaller and more knobbly than the domesticated varieties, but bursting with a fresh, sherbet flavour.

As autumn begins to 'fill all fruit with ripeness to the core', the Kent forager is spoiled for choice: bullace, sloe, elderberry and damson can be eaten from the tree, cooked into crumbles or preserved in jams or chutneys. Why not make an autumnal liqueur like sloe gin or damson brandy? The bright berries of rowan and hawthorn, although too bitter to eat raw, make delicious, tangy jellies as do the various hedgerow crab apples; alternatively, these can be added to soft fruit jams to aid setting. The irrepressible bramble now proves its worth with an abundant crop of blackberries, rich, warm and packed with vitamin C, like the hips of the dog roses (also rich in vitamins A and D) that can be transformed into a fragrant, soothing syrup. Even in the winter months, there is good to be gathered by the determined forager: ripe acorns, once leached in water to remove their natural tannins, can be roasted and ground for flour or to make acorn 'coffee'. Likewise, the sweet chestnut – so prized in Italian cuisine – which can also be candied, puréed or simply eaten as a treat, out of their shells, hot from the fire. Pinecones contain dozens of edible seeds and their needles can be made into pine needle tea, while beech mast and cobnuts can be harvested for storing or eaten fresh from the trees as they ripen.

HONEY

Thanks to the wandering habits of humankind, honeybees, which are thought to have originated in Asia, are now to be found on all the earth's continents except for Antarctica. *Apis mellifera*, or the European bee, has been producing honey in Europe and Asia for around 30 million years and it seems that humans have long been enjoying the rich, sweet confection: 8,000-year-old cave paintings in Cuevas de la Araña, Spain, depict humans foraging for honey and there is mention of honey in the mythology of many ancient cultures, including Egyptian, Greek and Hindu texts.

During temperate times of the year, the honeybee feeds on high-carbohydrate nectar and protein-rich pollen, which is then converted into honey. This vital food source is stored in readiness for winter feeding and times of dearth in the familiar honeycomb, each hexagonal cell of which is wax-capped for freshness. Most microorganisms do not grow in honey, so these tiny, sealed honey pots will not spoil, even after thousands of years. As well as being a delicious, sweet foodstuff (honey gets its sweetness from the monosaccharides, fructose and glucose, and has about the same relative sweetness as sucrose) honey also has antibacterial, antifungal and antiseptic properties; it can be used to soothe a sore throat or skin irritations, and wounds and burns have been shown to benefit from its topical application. When eaten, honey works to boost immunity and it has also been shown to relieve some seasonal allergies.

All the Kent farmers mentioned in this book strive to encourage and maintain healthy honeybee colonies on their land and many produce enough farm honey to sell. Wild food forager Michael White manages a small colony of thirteen hives, which he offers for pollination duties in orchards around his Wealden home. He describes the variations in local honey across the year as the bees' available food sources come into flower: spring honey, produced from blossoming hedgerow hawthorn and bramble, combined with wild and farmed plum, cherry and almond blossoms, tends to be light

(Photograph Claire Eckley)

in colour and has a mild flavour; clover honey is similar to this. In the predominantly arable farming areas, the field crop determines the honey's characteristics: one derived from field beans is darker in colour and has a more pronounced flavour than one derived from oilseed rape. However, a honey derived from aphid honeydew in areas of chestnut coppice is deeply dark and has a distinctly tangy flavour. This sort of honey might be an acquired taste but is extremely popular – and valuable – across the continent. Incidentally, if you have noticed crystallisation occurring in your honey, this happens naturally over time but can be easily reversed by gently warming the honey jar in a bowl of hot water before use.

LAVENDER

Lavandula angustifolia – from Latin *lavare* ('to wash').

Also known by the folk-names 'Spikenard'; 'Spike Lavender' and 'Elf Leaf'.

Culpeper tells us that lavender is good for a raft of common ailments, including headaches, dizziness and fainting, and he recommends it as a treatment for pain and muscle spasms. Its antibacterial properties also make lavender a valuable element of the household first aid kit.

Lavender is one of the county's more unusual culinary delicacies.

If you hop onto a Victoria or Blackfriars-bound train from the depths of Kent in July, you are likely to be struck by two things as you gaze at the countryside rolling past the window: one, the landscape of this county is truly beautiful and, two, some of its 'green and pleasant' fields are actually ... purple! That's because Kent is home to the UK's largest producer of lavender. But what (I hear you ask) is the place of the world's favourite perfume in a book devoted to edible delights? The answer lies at Castle Farm, near Sevenoaks, where the Alexander family has pioneered a unique Lavender essence which has taken the culinary world by storm and, in the kitchens of a number of local, artisan producers has led to the creation of some amazing, lavender-infused delicacies ranging from fudge and chocolate to marmalade, chutney and tea.

After moving their dairy herd (by rail!) from Scotland to Kent in 1892, the Alexanders worked for a century, farming a varied, mixed operation on the chalk slopes of Shoreham. Never afraid to experiment, in 2000 the family planted lavender for the production of essential oils by steam distillation and, in the process, discovered the possibilities of lavender foods – and they haven't looked back. Although still very much a busy, traditional, mixed farm (and now with a thriving 'Pick Your Own' orchard of rare apples), Castle Farm is renowned, locally and with its many admirers across the globe, for its fragrant star attraction, especially in late June and July when the lavender fields dazzle in a blaze of imperial amethyst.

An appreciation of the subtle differences between types of lavender is key to successful use of the herb in both sweet and savoury foods. The traditional English lavender (*Lavandula angustifolia*) with its soft, fragrant warmth is ideally suited to sweet treats and relaxing beverages, whereas the more sharply refreshing Lavandin (*Lavendula x intermedia*) – widely grown in Provence – works well with more robust, savoury flavours and partners particularly well with tomato. Castle Farm proprietor Caroline Alexander recommends trying a combination of crushed coriander seed with some lavender flowerbuds and using them in a tomato sauce with chicken or fish; as she explains, 'the coriander and lavender perfectly complement one another and take the humble tomato to a different level. The combo is great for home-made chutneys too!'

CHOCOLATE

In the quiet seclusion of the Weald, there is a small industrial kitchen working wonders with cocoa. The Simpson family set up their Goupie brand chocolate-making business in 2010. Based on an old family recipe, and working from the family home kitchen, the business started very small but soon expanded into industrial manufacturing premises, where they employ a dedicated, skilled team of four. Their products are made entirely by hand and are sustainably packaged, low sugar, gluten free and vegan. With its distinctive branding and memorable tagline – 'devilishly moreish chewy chocolate confection with a hint of crunch' – Goupie is certainly a stand-out product and, with eighteen classic and original flavours, there's something for everyone in the award-winning Goupie range, including two combinations created in collaboration

with Castle Farm in Shoreham – the dark chocolate English Lavender, infused with the lavendin oil, and White Lavender, which incorporates lavender flowers. But you won't find Goupie on any old supermarket shelf; for these exquisite treats, you need to shop locally (as they sell through many farm shops and delicatessens across the county) or visit their website or flagship shop, The Goupie Chocolate House, in Tunbridge Wells.

(Photograph Goupie)

Farmers' Markets and Foodie Festivals

FARMERS' MARKETS

There are around fifty different farmers' markets in operation in Kent; most are held once a month, but a few run every week and there is a permanent market in Canterbury, at The Goods Shed. The Kent Farmers' Market Association was established in 2007 as part of a well-researched project to organise and revitalise the disparate and fragmented network of independent farmers' markets that existed at that time. The KFMA has grown to become the largest of its kind in the country, offering small-scale and artisan producers an opportunity to sell their produce directly and without steep overheads or high financial risk. These markets allow shoppers a wide range of choices and seasonal produce at a reasonable cost, as well as the reassurance of being able to talk directly with producers about the foods they are buying. In some rural communities a regular farmers' market provides an essential replacement for a closed or non-existent village shop.

Bridge Farmers' Market. (Photograph Severien Vits for KFMA)

Wye Farmers' Market.
(Photograph Severien
Vits for KFMA)

FOOD FESTIVALS

I know, think 'festival', think wet tents and muddy wellies, but there are more appealing ways to enter into the carnival spirit: all across Kent, throughout the year, there are food and drink festivals celebrating local, national and international food producers, suppliers, distributors and importers. Many incorporate elements of entertainment and music and some offer demonstrations, workshops and culinary 'experiences' to complement exciting foodie displays and vibrant food markets. Whatever your gastronomic partiality, you can be sure there will be something to tempt the tastebuds at any one of Kent's many foodie fiestas around the year. These festivals are free to attend and represent some of the very best that the county has to offer in food and drink.

TONBRIDGE FOOD FESTIVAL – MAY

This gathering of fifty-plus food and drink producers is held in the grounds of Tonbridge Castle, along the banks of the River Medway. If you are inclined to bake, you could enter the Great Tonbridge Cake Off or those with a wanderlust could eat their way around the world at the Street Food Café. From fresh vegetables to Cajun sauce, from ethically sourced coffee to gourmet dog treats, this early summer fiesta kicks off food festival season and offers family activities, as well as a range of demonstrations by local chefs and producers.

THE FOOD FEST – JUNE

Visitors to the Food Fest, which takes place in different venues around the county each year, are entertained by a talented showcase of unsigned music acts while being

The Food Fest.
(Photograph
Clairey
Hearnden)

well catered for by a plethora of award-winning street food vendors and vintage food trucks. From a traditional hog roast and local craft beers to Turkish foods and a circus bar, there is something for everyone in this colourful, original and eclectic mix. Children are not forgotten as the Kids' World offers activities from street art to circus acts and there is even the opportunity to organise a unique festival wedding.

HYTHE FOOD FESTIVAL – JULY

The Hythe Food Festival, held at the height of the summer, takes place in the tranquil setting of Holman's Field, alongside the historic Royal Military Canal. As well as the huge variety of produce on offer, there are cookery demonstrations and a jazz night included in this weekend extravaganza.

WHITSTABLE OYSTER FESTIVAL – JULY

25 July, feast day of St James the Great, patron saint of oyster fishers, has long been the date upon which the people of Whitstable express their gratitude for the year's harvest. Today, while the ancient tradition of thanksgiving is still observed, the Saturday morning oyster blessing now signals the opening of a four-day festival encompassing celebrations of food, culture and community. Family fun events such as a costumed parade, art competitions and the 'mud tug' (of war) provide plenty of entertainment to complement the food festival, and the town's streets are lined with stalls selling (and revellers eating!) locally sourced oysters. Some of the star attractions of the festival are the 'grotters', small hollow piles of empty oyster shells that serve as candle lanterns to provide magical illuminations as the sun sinks below the waves.

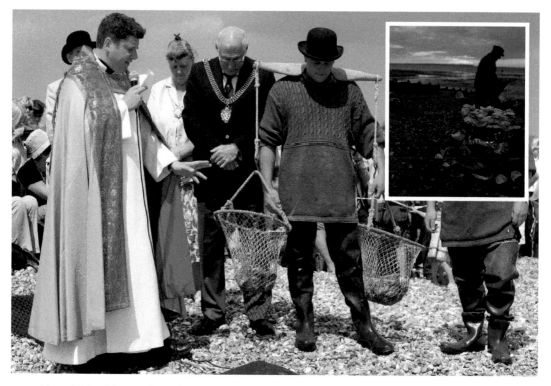

Above: 'I Bless This Catch'. (Whitstable Oyster Festival; licensed under Creative Commons BY 2.0)

Inset: 'Grotters Glow at Sunset'. (Whitstable Oyster Festival; licensed under Creative Commons BY 2.0)

THE FOLKESTONE TRAWLER RACE – AUGUST

This summer weekend festival includes lots of silly fun and games but is, at its heart, a celebration of Folkestone's fishermen – past, present and future. It is a chance to sample and buy fresh fish on the quay and to learn more about the heritage behind the community. One of the highlights for food enthusiasts is Mison's Annual Fish Pie Competition, for which contestants are challenged to bake 'Folkestone's best fish pie'.

ROYAL TUNBRIDGE WELLS FOOD MONTH – SEPTEMBER

During September, Edward VII's favourite Kent town is transformed into the county's epicurean epicentre. This month-long celebration of all things culinary includes two food festivals, four markets and a beer weekend, along with workshops, masterclasses and special events hosted by the town's myriad restaurants and eateries. At the beginning of the month, the Pantiles Harvest Food Festival is held in the town's historic Georgian colonnade and the four weeks culminate with the Royal Tunbridge Wells Food Festival, which takes place in the splendid Calverley grounds in the centre of

town. Both events feature food and drink producers offering tasters, demonstrations and lots of ideas for your own cooking adventures. The Tunbridge Wells Beer Weekend is a true team effort and presents beer aficionados with numerous opportunities to sample the beery delights on offer around the town, as well as enjoy quizzes, talks and special events at each of the partner venues.

CANTERBURY FOOD AND DRINK FESTIVAL – SEPTEMBER

As the summer slips languidly into autumn and wayward thoughts begin to stray towards the winter ahead, Canterbury offers a gastro-extravaganza to ward off any post-summer holiday blues. The Canterbury Food and Drink Festival, held in the city's Dane John Gardens every September, brings together producers from across the county in a three-day culinary showcase. From baked goods and coffees to olive oils and vodkas, the variety of goods on offer at the festival is astonishing, and many of the producers in attendance are Taste of Kent Award-winners. As well as the amazing array of produce available, the festival also boasts live music throughout the day, as well as a range of food-themed events for those who want to satisfy their curiosity as well as their taste buds. In previous years, these have included cooking masterclasses, foraging and wild food cooking workshops and informative talks and lectures.

HOPS 'N' HARVEST BEER FESTIVAL – SEPTEMBER

The Kent Life Heritage Farm Park is situated in part of the historical Allington Castle estate and is one of Kent's few remaining working hop farms. Every September, the park is host to a harvest festival like no other, where visitors can try their hand at hop picking and take a tour of genuine hoppers' huts and a traditional, coal-fired oast house. As well as the Kent beers on offer, there are also locally produced ciders plus a variety of foods and everything is accompanied by live music and entertainment.

DEAL FOOD AND DRINK FESTIVAL – SEPTEMBER

Held in the historical setting of the sixteenth-century castle, the Deal Food and Drink Festival is a vibrant showcase of current trends and exciting producers in the Kent food industry, offering dishes and drinks from across the globe, accompanied by live music and family activities.

CRANBROOK APPLE FAIR – OCTOBER

As the 'season of mists and mellow fruitfulness' begins to weave its golden magic through the orchard boughs, the Cranbrook Apple Fair, a celebration of 'everything appley', takes

over the town's historic High Street. The fair boasts an array of orchard fruits and local cider for sale, as well as apple juice pressed on site and a host of other entertainments. Morris dancers, stilt walkers and street musicians bring a true carnival atmosphere to proceedings and there are usually competitions and prize givings throughout the day. The annual Apple Fair prides itself on its quirky eccentricities and sense of fun but, at its heart, this is an enthusiastic community celebration of one of the staples of Kent's farming tradition.

(Photograph Graham Haskett)

One Final Thought

In our culturally kaleidoscopic lives, one can travel the world on a plate. From New Zealand to Norway, from China to Chile, the edible wonders of the world are within everyone's reach on any British high street or supermarket shelf. With such choice of exotic produce, food, today, can be a far-flung adventure and journey of delicious discovery, but there is also an abundance of culinary riches right on our own doorstep. Perhaps what has come through most strongly while researching and writing this book is that, universally, food and drink bring us together. In our families and our communities, we gather to eat and drink at the very best and the very worst of times; few grand celebrations pass without the raising of a glass or the cutting of a cake and even the most intimate get-together usually involves boiling the kettle. 2020 and 2021 will be seared in the memories of most as years of separation and isolation – and so many of our longed-for reunions will revolve around some version of a shared repast. The familiar dishes we rely on, the foods we hanker for when we're away, the meals we savour in our memories, these are the things we come back to, the things we depend on for our sustenance and our comfort; and there is very little that surpasses a taste of home.

Acknowledgements

Research for this book began in earnest at the start of 2020, and then the world fell off its axis and closed its doors as the extraordinary circumstances of the Covid-19 pandemic took hold. However, the food and drinks producers of Kent are a friendly bunch and I have encountered nothing but tremendous enthusiasm and generosity while conducting my research. I am extremely grateful to all those kind and patient individuals who took the time and care to answer my emails and phone calls; many have also allowed me to use their own photographs as illustrations.

My sincere thanks go to the following, without whose help this book would simply not have come together:

Michael White, Johnny Homer, Pippa Palmar, Derek and Judy Tolman, Michael Dalloway, Yvonne Archer, Gail Duff, Jo Williams and Ali Capper, Vikki Eames, Alexander Hunt, Tom Lupton and Anna Foster, Rob Cursons and Kim Reason, Lorna Roberts and Caroline Alexander, Darren Jenkins, Cath Mison, Claire Eckley, Grace Simpson, Pauline Skinner, Julie Murray, Severien Vits, Mark and Serena Henderson, Molly Cowden, Emily Pennington, Will Boscawen, Stuart Axford, Christine Warren, Fiona and Graham Haskett, Gillian Jones, Meg Game, Jeremy Stevens, Flemming Thorninger, Carole Trowbridge and Jerry Ash.

Thanks, also, to my family for their loving support.

Further Information

For further information on some of the products and producers mentioned in this book, please see:

Chapter 1: Hops and Brewing, Wines and Spirits
 The British Hop Association – www.britishhops.org.uk
 Shepherd Neame Brewery Ltd – www.shepherdneame.co.uk
 Anno Distillers – www.annodistillers.co.uk
 Marourde and Mereworth – https://mereworth.co.uk/

Chapter 2: Orchard Fruits; Soft Fruits and Nuts
 Kentish Cobnuts Association - kentishcobnutsassociation.org.uk
 Potash Farm Cobnuts – www.kentishcobnuts.com
 Rent a Cherry Tree – rentacherrytree.co.uk
 Kentdowns.org.uk (for more information on the 'Orchards for Everyone'
 project)
 Hugh Lowe Farms (for delicious soft fruits) – www.hughlowefarms.com
 Bernwode Fruit Trees – http://www.bernwodefruittrees.co.uk/about.htm

Chapter 3: Fruits of the Sea
 Jenkins & Sons, Deal – www.jenkinsandsonfishandgame.co.uk
 Folkestone Festival – https://www.folkestonefestival.org/
 Simply Oysters – https://simplyoysters.com/

Chapter 4: Arable and Pasture
 Eckley Farms – https://purekent.co.uk/
 Snoad Farm – http://www.snoadfarm.webeden.co.uk/
 Aragon Farm – https://www.aragonfarm.co.uk/

Chapter 5: Baked Treats
 Speciality Breads Ltd – www.specialitybreads.co.uk

Chapter 6: Wild Wonders and Unexpected Delights

> Rural Courses (for expert tuition in foraging and wild food preparation) – www.ruralcourses.co.uk
> Castle Farm, Shoreham (for all things lavender) – www.hopshop.co.uk
> Goupie – https://goupiechocolate.com/

Chapter 7: Farmers' Markets & Food Festivals

> Kent Farmers Markets Association – https://www.kfma.org.uk/Home
> Food Fest – https://thefoodfest.com/
> Canterbury – https://www.facebook.com/CTFoodFest/
> Tunbridge Wells – https://www.facebook.com/TunbridgeWellsFood andDrinkFestival/
> Tonbridge – https://www.facebook.com/TonbridgeFarmersMarket
> Hythe – http://hythelife.org.uk/food-fest-2021/
> Whitstable Oyster Festival – https://www.whitstable.co.uk/whitstable-oyster-festival-an-experience-not-to-be-missed

Bibliography

http://www.bbc.co.uk/kent/voices/hartlake/news_report.shtml [accessed 06.01.2020]

http://www.bbc.co.uk/kent/voices/living.shtml [accessed 06.01.2020]

https://books.google.co.uk

Boys, John, *General View of the Agriculture of the County of Kent: With Observations on the Means of its Improvement* (1804), https://archive.org/details/b22037585/page/128/mode/2up [accessed 06.01.2020]

Breverton, T., *Breverton's Complete Herbal* (London: Quercus, 2011

Bridge, John W., F.S.A., 'Maidstone Geneva. An Old Maidstone Industry', *Archaeologia Cantiana*, Volume 65 (1952), pp. 79–85

https://www.britishhops.org.uk/hops/history/kent-south-east/ [accessed 02.03.2020]

Bunyard, George, *Apples and Pears* (1911)

Culpeper, N., *Compleat Herball 1653* (Wordsworth, 1995)

http://www.theenglishappleman.com/journal2018-07-06-Growing-Cherries-in-Henry-VIIIs-orchard.asp [accessed 06.01.2020]

https://www.favershamhopfestival.org/index.php/hop-picking-in-faversham [accessed 06.01.2020]

Gibson James M., *Records of Early English Drama, Kent: Diocese of Canterbury* (University of Toronto Press, 2002)

http://www.gutenberg.org

http://www.gutenberg.org/files/36589/36589-h/36589-h.htm [accessed 23.03.2020]

Harper, Charles G., *The Dover Road, Annals of an Ancient Turnpike* (1922)

Hasted, E., *The History and Topographical Survey of the County of Kent* (Canterbury, 1798)

Hasted, E., 'Parishes: Biddenden', in *The History and Topographical Survey of the County of Kent: Volume 7* (Canterbury, 1798), pp. 130–141. British History Online http://www.british-history.ac.uk/survey-kent/vol7/pp130-141 [accessed 3 March 2020].

Hasted, Edward, 'Parishes: West Wickham', in *The History and Topographical Survey of the County of Kent: Volume 2* (Canterbury, 1797), pp. 29–37. British History Online http://www.british-history.ac.uk/survey-kent/vol2/pp29-37 [accessed 7 June 2021]

https://herbaria.plants.ox.ac.uk/bol/plants400/Profiles/gh/Humulus [accessed 02.03.2020]

http://hoppingdowninkent.org.uk/whykent.php [accessed 06.01.2020]

Jordan, W. K., 'Social Institutions in Kent 1480–1660, The structure of Aspirations, The Poor', *Archaeologia Cantiana* Volume 75 (1961), pp. 16–55

https://www.kent.gov.uk/__data/assets/pdf_file/0014/12461/Landscape-Assessment-of-Kent-October-2004_Part1.pdf

https://www.kent.gov.uk/__data/assets/pdf_file/0015/12462/Landscape-Assessment-of-Kent-October-2004_Part2.pdf

https://www.kentinvictachamber.co.uk/news/fish-local-campaign-supports-kent-fishing-industry/

Simmonds, M., Howes, M., and Irving, J, *The Gardener's Companion to Medicinal Plants* (Frances Lincoln, 2016)

https://www.telegraph.co.uk/news/earth/countryside/8734914/Hop-growing-in-the-Garden-of-England.html [accessed 06.01.2020]

Turner, B., *The Complete Home Winemaker & Brewer* (London: Guild, 1986)

https://www.victorianlondon.org/entertainment/ginpalaces.htm [accessed 02.04.2020]

https://en.wikisource.org/wiki/Sketches_by_Boz/Gin-shops [accessed 02.04.2020]

Notes

1. Whyman, John, *Agricultural Developments 1700–1900* in Lawson, T. and Killingray, D. (ed.) *An Historical Atlas of Kent* (Phillimore, 2004), pp. 108–9.
2. *House of Lords European Union Committee, Brexit: Agriculture*, House of Lords Paper 169, May 2017 pages 36-37.
3. At present, it is generally accepted that the earliest known example of a purpose-built hop garden is one at Westbere, near Canterbury, first recorded in 1523.
4. Boorde, Dr Andrew, *The Fyrst Boke of the Introduction of Knowledge*, c. 1547.
5. Boys, John, *General View of the Agriculture of the County of Kent: With Observations on the Means of its Improvement*, 1804 https://archive.org/details/b22037585/page/128/mode/2up [accessed 7 June, 2021].
6. There is much academic debate about the 'Roman Climatic Optimum' theory, but recent studies suggest that, between *c.* 250 BCE and *c.* 400 CE, temperatures across Europe and as far north as Iceland were roughly equivalent to those experienced at the turn of the twenty-first century.
7. Defoe, Daniel, *A Brief Case of the Distillers and of the Distilling Trade in England* (London: T. Warner, 1726) pp. 25–27.
8. Miller, Thomas, *Illustrated London News*, May 6, 1848.
9. Dickens, Charles, *Sketches by Boz*, 1836.
10. Grant, Thomas, handbill of 1857, in Bridge, John W., F.S.A., 'Maidstone Geneva. An Old Maidstone Industry', *Archaeologia Cantiana* Vol. 65 (1952): p. 83.
11. Dickens, Charles, *The Pickwick Papers*, Ch XXII, 1836 https://www.gutenberg.org/files/580/580-h/580-h.htm
12. William Lambarde, *A Perambulation of Kent: Conteining the Description, Hystorie, and Customes of that Shyre, Written in the Yeere 1570*.
13. Gibson, James M; Kent: Diocese of Canterbury 2: *The Records of Early English Drama* British Library https://archive.org/details/kentcanterREED02gibsuoft/page/n305/mode/2up [accessed 3 March, 2021]
14. Edward Hasted, 'Parishes: West Wickham', in *The History and Topographical Survey of the County of Kent: Volume 2* (Canterbury, 1797), pp. 29-37. British History Online http://www.british-history.ac.uk/survey-kent/vol2/pp29-37 [accessed 7 June 2021].

15. I am indebted, for these descriptions, to Derek and Judy Tolman, of Bernwode Fruit Trees. Their comprehensive catalogue contains details of hundreds of varieties of apple and fruit trees: http://www.bernwodefruittrees.co.uk/about.htm.

16. Lambarde, William, *A Perambulation of Kent, Conteining the Description, Hystorie, and Customes of that Shyre* (London, 1576), p. 4.

17. Taylor, H. V., in Grubb, Norman H., *Cherries* (London, 1949), p. v.

18. Houseman, A.E., *A Shropshire Lad*, 1887.

19. https://e360.yale.edu/features/feeling-the-heat-warming-oceans-drive-fish-into-cooler-waters [accessed 30 June, 2021].

20. Pegge, Samuel, *The forme of cury, a roll of ancient English cookery, compiled, about A.D. 1390, by the master-cooks of King Richard II, presented afterwards to Queen Elizabeth, by Edward, lord Stafford, and now in the possession of Gustavus Brander, Esq.* https://www.gutenberg.org/cache/epub/8102/pg8102.html [accessed 12 June, 2020].

21. Dickens, Charles, *The Pickwick Papers*, Ch XXII, 1836 https://www.gutenberg.org/files/580/580-h/580-h.htm

22. Edward Hasted, 'Parishes: Biddenden', *in The History and Topographical Survey of the County of Kent: Volume 7* (Canterbury, 1798), pp. 130–141. British History Online http://www.british-history.ac.uk/survey-kent/vol7/pp130-141 [accessed 10 June, 2020].

23. Ibid.

24. Harper, Charles G. *The Dover Road*, (C. Tinling & Co. Ltd., 1922), p. 238.

25. Cobbett, William, *Rural Rides* (London, 1830), p. 217